" The terrible truthfulness of this statuette
is a source of obvious discomfort for
them; all of their notions about sculpture,
about that cold inanimate whiteness, those
memorable stereotypes replicated for centuries,
are being overturned.

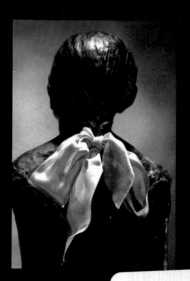

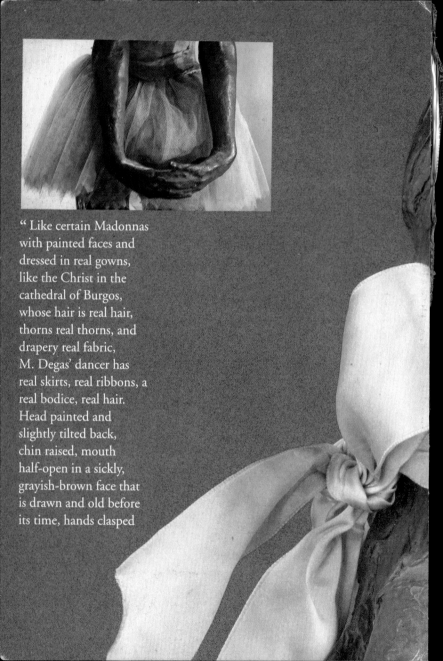

" Like certain Madonnas
with painted faces and
dressed in real gowns,
like the Christ in the
cathedral of Burgos,
whose hair is real hair,
thorns real thorns, and
drapery real fabric,
M. Degas' dancer has
real skirts, real ribbons, a
real bodice, real hair.
Head painted and
slightly tilted back,
chin raised, mouth
half-open in a sickly,
grayish-brown face that
is drawn and old before
its time, hands clasped

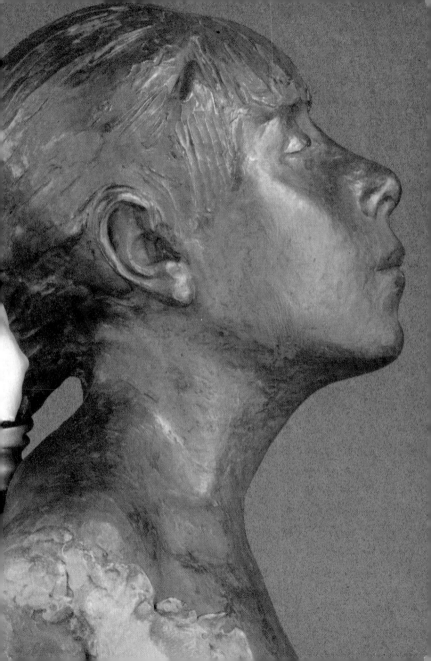

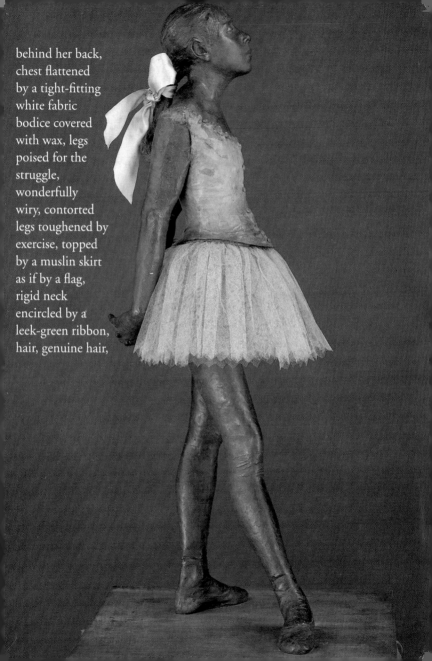

behind her back,
chest flattened
by a tight-fitting
white fabric
bodice covered
with wax, legs
poised for the
struggle,
wonderfully
wiry, contorted
legs toughened by
exercise, topped
by a muslin skirt
as if by a flag,
rigid neck
encircled by a
leek-green ribbon,
hair, genuine hair,

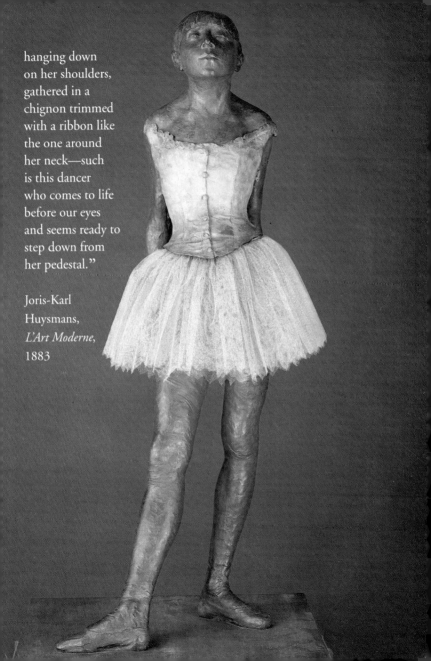

hanging down on her shoulders, gathered in a chignon trimmed with a ribbon like the one around her neck—such is this dancer who comes to life before our eyes and seems ready to step down from her pedestal."

Joris-Karl Huysmans, *L'Art Moderne,* 1883

CONTENTS

DEGAS
THE MAN AND HIS ART

Henri Loyrette

WITHDRAWN

DISCOVERIES

HARRY N. ABRAMS, INC., PUBLISHERS

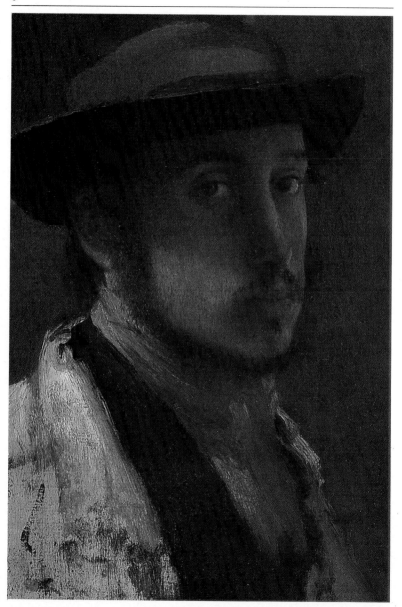

There is a section of Paris that used to be called "The New Athens" because of its many artists. This unofficial republic of the arts and letters was also popular with prostitutes, nicknamed *lorettes* because they plied their trade in the shadow of the church of Notre-Dame-de-Lorette. But the district was also attracting a more respectable element, including bankers, like Auguste De Gas. His son Hilaire Germain Edgar was born there on 19 July 1834.

CHAPTER I
AN ARTIST'S EDUCATION

Early in his career, Degas often used himself as a model. This self-portrait shows him at the age of twenty-three; he painted his last one when he was thirty-one.

A Romantic Forebear

The child was named after his paternal grandfather, Hilaire Degas, a banker who had settled in Naples, Italy, and his maternal grandfather, Germain Musson, a merchant living in New Orleans. Both of these remarkable figures, especially the former, were to exert considerable influence over the boy.

Later on, through an exercise in convoluted genealogy, the artist's family attempted to prove a link to nobility reaching back to the obligatory Crusader: This one supposedly put down roots in lower Languedoc (southern France). The truth was less romantic. Born in Orléans in 1770, Hilaire Degas was the son of one "Pierre Degast, baker." For reasons still not fully understood, he voluntarily exiled himself to Naples during the French Revolution. This was later seen in some quarters as a sign of his political leanings, but the most plausible version of this murky affair was the one Edgar himself, "in a reminiscent vein," recounted to poet and philosopher Paul Valéry in 1904.

Valéry reports: "[Hilaire] speculated in grain during the Revolution. One day in 1793, while conducting business at the Corn Exchange…a friend approached him from behind and whispered, 'Make yourself scarce! … Run for your life!…They're at your house.' There wasn't a moment to lose. Right then and there, he borrowed all the [money] he could lay his hands on, left Paris at once, wore out two horses racing to Bordeaux, and went aboard a ship that was about to sail. The ship called at Marseilles. There,

Degas made several trips to Naples, where he visited his paternal grandfather, Hilaire Degas (opposite). He loved Hilaire's adopted city, made the rounds of its treasure-filled museums, and toured Campania. In the spring of 1860 he sketched several views of the city in one of his notebooks (below: *View of Naples*) and added some notations about color. "The somewhat choppy sea was a greenish-gray, the foam on the waves silver— the sea receded into a mist. The sky was overcast, the Castello dell'Uovo rose in a mass of golden green…. It made for a northern effect, yet you could sense these sunny climes. Therein lay all its charm."

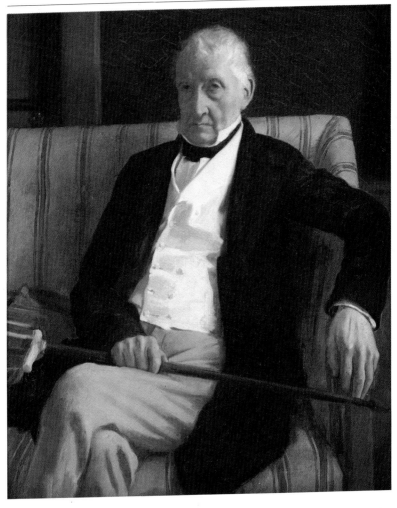

according to Degas' story (which I am careful not to interrupt), it took on a load of pumice, which struck me as implausible…. At last M. Degas reached Naples, where he went into business."

Hilaire Degas proved a resourceful businessman and quickly built up a veritable fortune in Naples. The first

In this incisive portrait of ripe old age, Degas captured his grandfather's stern but attentive expression in the symbolic glow of a setting sun.

thing he did was marry the daughter of his boss, a wealthy merchant from Genoa. By 1809 he had become a broker. In 1836 he and three of his sons would set up a banking firm, Degas Padre e Figli, with a Paris affiliate.

Hilaire purchased real estate in Naples and the surrounding region of Campania—the Palazzo Pignatelli di Monteleone, near the Piazza del Gesù Nuovo, and a villa in San Rocco di Capodimonte —for there was a growing brood to house: seven children in all. One by one, they married into old, if undistinguished, local aristocracy and started families of their own in Naples. Auguste, the eldest, was the only exception.

De Gas or Degas?

A Frenchman before he was a Neapolitan, Hilaire sent his firstborn son off to Paris to study. Auguste knew hardly any French when he set foot on French soil in 1825, but what was to have been a temporary arrangement turned out to be permanent. On 14 July 1832 Auguste De Gas—he had divided his last name in two to give it cachet (the painter reverted to the traditional spelling in the 1860s)—married eighteen-year-old Célestine Musson in the church of Notre-Dame-de-Lorette.

The Mussons had come to Paris from faraway America. The father of the bride, Germain Musson, had first moved from his native Haiti to New Orleans

Achille (above), the painter's handsome younger brother, was an unruly, impulsive boy. While attending the French Naval Academy, he was threatened with expulsion. He resigned in 1864 and settled in New Orleans, where his brother René and he founded the firm of De Gas Brothers.

and made a fortune in cotton. Born in 1815, Célestine was the youngest of five children he had with Marie Désirée Rillieux, the heiress of a good Louisiana family. According to the painter's first biographer, Paul-André Lemoisne, the young couple's romance blossomed in the garden separating their Paris homes. Glances led to pledges, and before long the two were married in their parish church.

Hilaire Degas set his son up in business. Auguste managed the Paris affiliate of Degas Padre e Figli. Célestine and he had five children over a period of eleven years: first Edgar, then Achille (1838), Thérèse (1840), Marguerite (1842), and René (1845), who would always be his big brother Edgar's favorite.

Edgar "in the Clouds"

The backdrop of Edgar's childhood shifted from the Saint-Georges district of Paris to the vicinity of the Luxembourg Gardens when his parents moved to Rue de l'Ouest (now Rue d'Assas) and from there to Rue Madame. His mother died soon thereafter, in 1847; it is hard to assess the impact of what must have been a tragic turn of events for a thirteen-year-old. Degas seldom mentioned her in later years, whereas he often reminisced about the man he referred to as his "dear papa."

Auguste De Gas never remarried and settled into a quiet life. Through his neglect and mismanagement, the family business languished and, after his death, collapsed. His real passions were painting and music.

On 5 October 1845 Edgar entered Louis-le-Grand, a secondary school on Rue Saint-Jacques, across from the

Degas and Paul Valpinçon first became friends at the Lycée Louis-le-Grand. Starting in the 1860s and throughout his life, he often summered with the Valpinçons at their country estate in Normandy. As we can see in this picture (above, 1861), the handsome features of his friend, "a kindly bourgeois from Orne [a department of France]," had already become puffy. (Degas mentions in a notebook that he weighed 54.5 kg., Valpinçon 94 kg.)

Left: Detail of a portrait (c. 1860) of Edgar's sister Marguerite, who did not pose for him as often as his beloved Thérèse. An accomplished musician, she had a "prima donna" side that contrasted with her sister's self-effacing propriety.

Sorbonne. He received all of his formal education—eight years of study—at this institution. The school's archives are the sole source of what little we know about these school years, punctuated by Sunday outings and interrupted by summer vacations.

Degas made satisfactory progress but proved a lackluster pupil; uncommunicative and often "in the clouds," he was reprimanded for carelessness. He got decent grades in drawing, but other pupils—especially his sidekick Paul Valpinçon, a lifelong friend—did as well as he, if not better. All in all, nothing would have led one to predict a painter of genius.

When school let out, Edgar and his father would regularly call on noted art collectors of the day, such as Eudoxe Marcille and Louis La Caze. These visits probably counted for more in Degas' education than the lessons parceled out to him in overcrowded classrooms.

Years later, when he painted *The Collector of Prints,* he harked back to this breed of a bygone day: the enthusiastic, passionate amateur who was more intent on acquiring art than displaying it, in contrast to the undiscriminating newly rich who paid huge sums for works of art that they accumulated solely for their commercial value.

A Manifest Calling

We are still baffled by the fact that Degas decided what his chosen field would be so quickly after completing his schooling. He left Louis-le-Grand on 27 March 1853; a few days later, on 7 April, he was given permission to copy at the Louvre.

His father could not help feeling uneasy about seeing his eldest son—the one he expected one day to take over the family's business—embark upon a painting career. To appease the older man temporarily, Edgar registered for law school in November 1853. Years later, in May 1899, Degas, who was reluctant to reveal anything about his early years, confessed to his friends the Halévys that he had in fact studied law but was

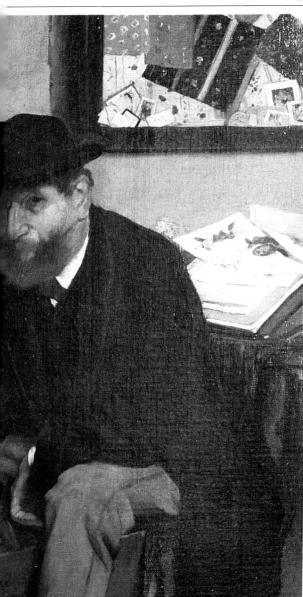

In *The Collector of Prints* (1866), Degas portrayed what was thought even then to be a vanishing species: collectors who bought out of love for art, regardless of its monetary value—the kind of collector Degas himself was to become a few years later. More interested in ferreting out inexpensive pictures than in building up an important collection, the man shown here is rummaging through an untidy portfolio in a secondhand shop and culling prints by Pierre-Joseph Redouté (famous for his pictures of roses). Degas later reminisced about the times his father and he would call on collectors, including Eudoxe Marcille. "[Marcille] sported a hooded cape and a worn-out hat. People all wore worn-out hats back then."

drawing "all the primitives in the Louvre the whole time" and had ended up admitting to his father that he could not go on. At any rate, he did not re-register for law school.

First Steps in His Chosen Field

A little later, reportedly on the advice of Edouard Valpinçon—collector, friend of Ingres, and the father of his schoolmate Paul—Degas attended classes with painter Louis Lamothe (1822–69). Lamothe was a disciple of painter Hippolyte Flandrin.

Degas had Lamothe to thank for his real grounding, his love of drawing, his reverence for 15th- and 16th-century Italian masters (a passion, it is true, he shared with Auguste De Gas). An honorable, if rather unimaginative, artist, Lamothe was in large measure responsible for Degas' deep-seated integrity as a painter, his penchant for well-crafted work, his dogged perseverance.

On 5 April 1855, when he was admitted to the prestigious Ecole des Beaux-Arts, placing thirty-third in the entrance competition, Degas still used Lamothe's name as a reference. Not until 1859 did the fledgling artist dissociate himself from the man who had been his teacher.

Information about Degas' brief stint at the Ecole des Beaux-Arts is sketchy; we do not even know whose classes he attended. When he failed to return for a second semester, he irrevocably passed up all the advantages the school's curriculum had to offer, above all a chance at the Prix de Rome. Prix de Rome laureates spent several years studying at the Villa Medici, in Rome, and on their return were assured of a career facilitated by commissions from the French government or from private clients who leaned toward prizewinning artists out of sheer conformity.

It is true that Degas had the wherewithal to undertake an independent tour of Italy and could afford to dispense with a form of instruction he obviously deemed less than worthwhile.

Like Degas four years before him, Louis Lamothe took his cue from Ingres when he painted this *Self-Portrait* in 1859. When Degas saw it, he recognized the progress he had made while in Italy. Lamothe was positively "sillier than ever," observed Degas; the teacher was stagnating while his pupil was making rapid strides.

Meeting Ingres

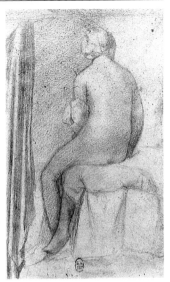

Paul Valéry recounts:
"[Degas] once knew an elderly collector, a M. de Valpin[ç]on—a charming name, a name out of the music-hall—who was a great devotee and friend of Ingres.

"Degas said the following took place in 1855.

"One day, he called on this Valpin[ç]on and found him somewhat troubled.

"'Ingres just left looking very offended,' he said. 'I refused to lend him one of his pictures for an upcoming exhibition. I was afraid of a fire. The premises [the Palais des Beaux-Arts built for the Paris Exposition] are likely to go up in smoke.'

"Degas protested vehemently, implored Valpin[ç]on to change his mind, and finally won him over.

"The following day the two of them went off to the master's studio to tell him that the picture was his for the taking. While they were conversing, Degas scanned the walls. (At the time he told me this, he owned some of the studies he recalled seeing there.)

"As they left, Ingres bowed quite ceremoniously. Just then, he had a dizzy spell and fell flat on his face. When they picked him up, he was covered with blood. Degas washed him and then rushed to the Rue de l'Isle to fetch Mme. Ingres. He gave her his arm and escorted her back on foot to No. 10, Quai Voltaire.

"There they found Ingres coming downstairs, still quite shaken. The next day Degas called to inquire after him. Mme. Ingres received him most graciously and showed him a picture.

"Some time later, M. de Valpin[ç]on begged Degas to

Degas met Ingres (left) in the spring of 1855, a milestone occasioned by the retrospective of the master's work at the Paris Exposition. This photograph by Pierre Petit shows the painter shortly before he died.

Above: Degas made numerous copies of Ingres' work at the Exposition, among them *The Bather*, then owned by Edouard Valpinçon. He professed great admiration for Ingres his whole life long, constantly harked back to the older man's observations and precepts, and paid small fortunes for several of his masterpieces.

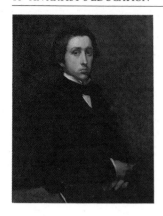

go back to Ingres and ask him to return the picture he had borrowed.

"Ingres replied that he had already sent it back to its owner. This time, however, Degas was determined to talk about himself. He told himself that he had to have a conversation with Ingres. He started off timidly and finally stated: 'I do some painting, I am just starting out, and my father, who is a man of taste and an art lover, is of the opinion that I am not a totally hopeless case.'

"'Draw lines...,' Ingres told him, 'lots of lines, either from memory or from nature.'"

"Another time," Valéry wrote in *Degas Dance Drawing*, his book about the painter, "Degas told me about this interview with one rather important variation. According to this version, he went back to see Ingres, as I stated above, but accompanied by Valpin[ç]on and carrying a portfolio under his arm. Ingres glanced through the drawings in it and, as he closed it, said, 'Right you are! Never from nature, young man. Always from memory and the engravings of the masters.'"

Valéry then notes that Degas registered these remarks without comment, obviously feeling that the application of Ingresque teachings—constantly draw lines, never study from nature, copy the old masters —was sufficiently self-evident in his work. Degas took the pithy precepts of the creator of the *Odalisque* for gospel truth.

That very year, when the aspiring painter used himself as a model, he copied the pose Ingres struck for his famous self-portrait in the Musée Condé at Chantilly.

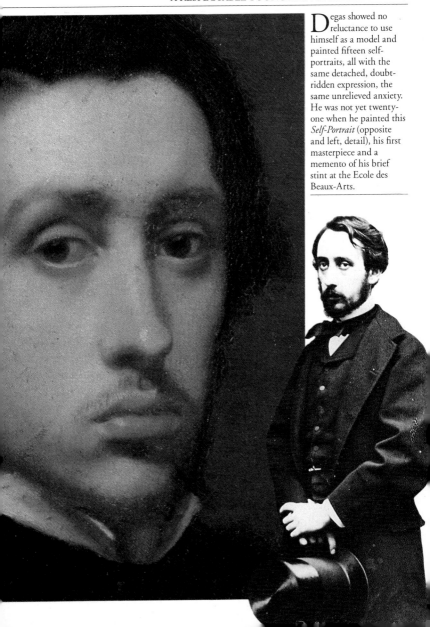

Degas showed no reluctance to use himself as a model and painted fifteen self-portraits, all with the same detached, doubt-ridden expression, the same unrelieved anxiety. He was not yet twenty-one when he painted this *Self-Portrait* (opposite and left, detail), his first masterpiece and a memento of his brief stint at the Ecole des Beaux-Arts.

The Labor of Copying

The painter now divided his time between copying—
in the Louvre, in the Print Room of the Bibliothèque
Nationale, at the Ingres retrospective at the Paris
Exposition—and painting portraits of family
members. To the one of his brother René in his
school uniform he added a book, some notebooks,
and a pen and inkwell to indicate his model's
occupation. In addition to quotations from books
and jottings of a more personal nature, Degas'
notebooks from this period include several sketches,
most of them quite rough, for history pictures that
were never carried to fruition.

There are, strictly speaking, no "works of
youth," to use what can be a highly reductivist
label. What Degas did was study tirelessly,
turning out the usual quota of compulsory
studio exercises under Lamothe (academy
figures from the nude and from sculpture), but
chiefly after the old masters—an inclination his
father could not help but encourage. In October 1854
in the Louvre he started copying *Portrait of a Young
Man,* then attributed to Raphael.

The following year he repeatedly copied the
masters, occasionally in oil but most of the
time in pencil. Later, he took an
uncompromising stand on this matter:
"The masters must be copied again and
again, and only after having given
every indication of being a good
copyist can you reasonably be given
leave to draw a radish from nature."

From Copies to Interpretations

What Degas was trying to capture
in the work of his predecessors
was correctness of expression, the
right formula, technical secrets he
hoped to be able to assimilate into his

Degas was interested
not only in the old
masters, but also in
Classical antiquity and
19th-century art. But he
kept coming back to
Italian Renaissance
painters. Witness this
copy (below) of *Portrait of
a Young Man,* then
attributed to Raphael.

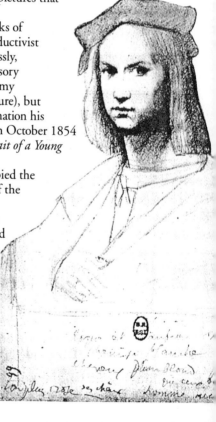

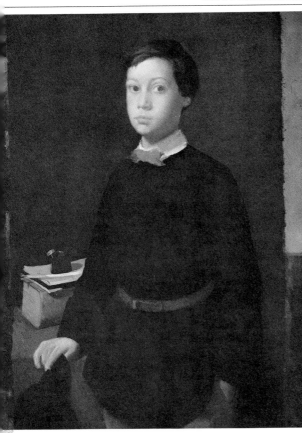

As a rule, only members of Degas' immediate circle sat for portraits. The single exception, Mme. Dietz-Monnin, proved so troublesome that he resolved not to accept another such commission. Early in his career, he turned to relatives—brothers, sisters, uncles, aunts, and cousins both male and female—time and again for portrait subjects. His father, who kept close tabs on his son's progress, is conspicuous by his absence. "The masters of the 15th century are the only true guides," wrote Auguste De Gas. "When they have clearly left their mark on an artist and motivated him constantly to perfect his study of nature, he is bound to get results."

Left: The youngest member of the family, shown here in *René De Gas* (1855), and Thérèse were undeniably Degas' favorites. René recalled much later that whenever he came home from school, he no sooner put his books down than Edgar got hold of him and made him pose.

own work. He deftly distilled from the masters he studied the inevitable biases that are the essence of a manner, a painter's style: "No bias in art? What about the Italian primitives who use hard lines to simulate the softness of lips and who bring eyes to life by cutting off the eyelids, as if with a pair of scissors?"

In 1858 or 1859, in Florence, he used pencil to copy *Portrait of a Young Woman*, a red-chalk drawing then attributed to Leonardo da Vinci. He then took brushes in hand and, assuming the role of Leonardo, finished on canvas what the master had only sketched.

A little later, his encounter in the Louvre with Nicolas Poussin's *The Triumph of Flora* (c. 1627) did not result in a copy in the strict sense of the word, which would have meant using the identical medium, oil. Reverting instead to a 17th-century technique, he dashed off a sketch in pen and wash that could have been done by Poussin himself. He did this sort of thing time and again into the 1890s, when he and his friend Ernest Rouart copied Mantegna in the Louvre: not sterile, slavish, stale reproductions, but subtle variations on an old theme, the kind of exercises in style that were popular in the 19th century.

Degas' Tour of Italy, Prix de Rome or Not

In 1856 Degas decided to spend an extended period of time in Italy. This was by no means unexpected: He was simply following what had been since the 17th

century a well-established French tradition of diligent study of Italian masters as well as ancient Roman art. But Degas' sojourn in Italy, comparable in both duration (three consecutive years) and purpose to those of French students in Rome, subsequently aroused suspicion in critics who saw it as nothing more than an infusion of academicism. Even if Degas did not stay at the Villa Medici, on the whole the training he received was comparable to that of any Prix de Rome laureate. The works he produced during this phase have usually been dismissed by critics as abortive efforts reflecting a pointless aspiration to conformity, as proof positive that his genius had no need to saddle itself with the academic precepts and subjects he was to slough off in the 1860s, thanks to his fortunate association with Edouard Manet, Camille Pissarro, Henri Fantin-Latour, Paul Cézanne, and other heroes of contemporary painting.

Italy Was More Than Work. It Was Family, Too

By the time he set out for Naples in July 1856, Degas, though only twenty-two, was no longer a novice. To be sure, he still lacked self-confidence, which resulted in an awkwardness and an abrupt manner that occasioned teasing remarks from several of his friends. But he landed in Italy with a considered plan to make the customary tour, which meant dividing his time between visiting museums and galleries, studying Classical, Renaissance, and Baroque art, working in the studio, and traveling throughout the peninsula.

After spending some time with his grandfather at Hilaire's *palazzo* in Naples and villa at nearby San Rocco di Capodimonte, Degas left for Rome in the fall

During his long sojourn in Italy, Degas turned out a great many preliminary studies for a *St. John the Baptist and the Angel*, filling his notebooks with lightning sketches (left), rough drafts of overall views or single figures, and background studies. The result of all this work was one small watercolor, not what the many preparatory drawings would have led one to expect. We have only a general idea of what the subject was supposed to have been: Like Elijah before him, John the Baptist fulfills the mission of the Angel announced by the Lord—to prepare humankind for the coming of the Messiah; the angel guides him and speaks through him. Thus, one of the chief characteristics of Degas' history paintings—a calculated abstruseness not unlike that of the enigmatic works of the Renaissance —surfaced as far back as this initial attempt.

Opposite, below: Copies after the antique and various studies done in Naples and Rome in 1856.

and stayed until the following summer. Then, at his grandfather's urging, he returned to the "tiresome countryside of Capodimonte."

While in Naples, Degas could not help seeing a great deal of his father's side of the family: his uncles Edouard and Henri Degas, their father's partners in the family banking firm; Aunt Rosina (the Duchessa Morbilli di Sant'Angelo à Frosolone); Aunt Fanny (the Duchessa di Montejasi); and Laura, his favorite aunt and confidante, whose husband, Gennaro Bellelli, had been exiled to Florence from his native Naples. Degas sketched most of them at various stages in his sojourn. Though small, his portrait of Hilaire Degas (page 11), shown seated on a couch in his villa at San Rocco di Capodimonte, makes a lasting impression.

Under the influence of their director, Jean-Victor Schnetz, all the Prix de Rome laureates fell in with the fashion for picturesque Italian subjects. In 1856–7, Degas followed suit, though rather halfheartedly. There is no concession to fashion in *Roman Beggar Woman* (opposite, left); it is a patient study of a woman on whom Degas bestowed, to quote critic Hippolyte Taine, "the noble lineaments of an ancient people and bygone genius."

When in Rome...

Back to Rome. Now that his family was far away, he put portraiture aside for more conventional pursuits: history paintings (never completed), studies of "typical" natives (a common practice at the time), and copies after the antique and after the old masters. In addition to these academic exercises, he occasionally sketched landscapes in his notebooks or on loose sheets of paper.

His crotchety disposition notwithstanding—"Degas who grumbles and Edgar who growls," engraver Joseph-Gabriel Tourny (1817–80) noted with amusement—he mingled with French artists who were in Rome at the time. This small circle included not only

By minimizing references to the picturesque, refusing to condescend to facile exoticism, and focusing instead on everything that bespeaks the subject's poverty and old age—the ill-matching tatters, the shriveled face—Degas carried on the tradition of Diego Velázquez.

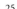

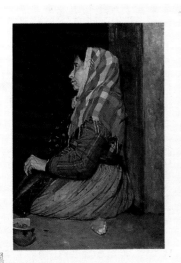

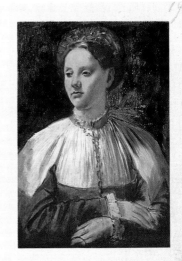

A Capodimonte landscape from one of Degas' Italian notebooks (1856). Above right: *Portrait of a Young Woman* (oil on canvas, 1858–9), copied in Florence after a red-chalk drawing then attributed to Leonardo da Vinci.

*Chiamavi il cielo, e intorno vi si gira,
Mostrando le sue bellezze eterne,
e l'occhio vostro pure a terra mira*

Prix de Rome laureates and recipients of other subsidies, but painters working for private clients as well as individuals who, like Degas, were paying their own way through Italy. Among the latter was Gustave Moreau, whom Degas probably first met early in 1858 and who was to be a major influence for the next several years.

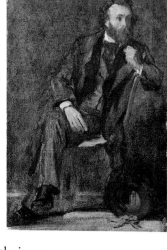

Aware that drawing would be his strong suit, Moreau was concentrating on color at the time; and this pursuit was of particular interest to Degas, who was developing along similar lines. He had Moreau to thank for relieving him of the burdensome instruction of Flandrin and Lamothe, for stimulating his insatiable curiosity about technique, and, in all probability, for

introducing him to the use of pastel. Lastly, it was through Moreau that Degas discovered the work of Eugène Delacroix, which tempered his admiration of Ingres: The young painter's reverence for line was now coupled with a newfound appreciation for color and movement.

An Introspective Degas on Holiday in Florence

During the summer of 1858 Degas traveled from Rome to Florence by way of Viterbo, Orvieto, Perugia, Assisi, and Arezzo. His beloved Aunt Laura, who was in Naples, had invited him to visit in her Florence apartment. But Laura and her two daughters were detained in Naples by the illness and death (31 August) of Hilaire Degas, so Degas ended up spending several months with Laura's husband, Gennaro Bellelli, of whom he was not overly fond, waiting for her to come

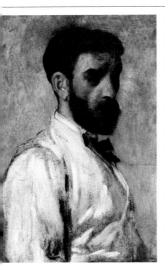

back. Lonesome and bored, the young painter, with "only himself in front of him, nothing but himself to look at, nothing but himself to think about," read Blaise Pascal's *Provincial Letters* (1656), "which recommends that we detest the self."

Back in Paris, Auguste De Gas, though starting to fret over Edgar's repeatedly postponed return, expressed satisfaction at the undeniable progress his son had made during his stay in Italy. "You have made tremendous strides in art," he observed on receiving *Dante and Virgil.* "Your drawing is strong, your colors are true. You have rid yourself of that limp, trivial Flandrinian-Lamothian linework, of that gray, leaden color. There is no need to keep tormenting yourself, my dear Edgar; you have set an excellent course."

Pleased with what he had seen, he made a point of mentioning the already striking originality of his son's efforts: "Set your mind at rest, and through calm but steady and unabating work persevere along this path you have chosen. It is yours and nobody else's. Work in peace, I tell you, stay on track, and rest assured that you will succeed in achieving great things. You have a bright future ahead of you; don't lose heart, don't worry yourself so." Auguste De Gas put his finger on an obvious weak spot in the budding artist's makeup: a tendency to doubt everything, including himself, to plunge impetuously into countless projects only to become discouraged if they failed to bear fruit.

When Edgar had let it be known that he found painting portraits "a bore," Auguste had retorted that

For a long time critics played down young Degas' friendships with Léon Bonnat and artists deemed too compromising for the man who went on to become a ground breaker. Degas was definitely a member of Bonnat's immediate circle and in 1863 painted two fine portraits of his friend, who he felt had something of the "Venetian ambassador" about him. He gave the more polished of the two to the sitter and kept this one (left, detail), which shows him at work. His tormented expression provides a happy counterpoint to the unflattering image we have of Léon Bonnat as a corpulent and pompous official portrait painter.

While in Florence Gustave Moreau drew his young friend Degas in the time-honored tradition of the aristocratic portrait, complete with studied pose and obligatory drapery effect (opposite below, left and right). In 1860, once they were back in Paris, Degas reciprocated with a portrait of his mentor in Italy as a man-about-town (opposite above).

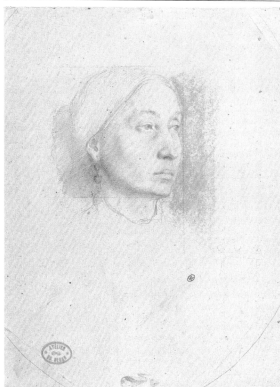

Degas began doing studies for *Family Portrait,* or *The Bellelli Family,* in the fall of 1858. The young painter had spent the entire summer in Florence waiting for his aunt, Laura Bellelli, who was detained in Naples by the illness and subsequent death of Hilaire Degas. He was bored and had no one to keep him company except his dull, peevish uncle, Gennaro Bellelli, and a few undistinguished artists who were passing through the Tuscan capital. Once his aunt and young cousins got back, everything changed. Inspired at various stages by Van Dyck, Giorgione, Botticelli, Rembrandt, Mantegna, and Carpaccio, Degas enthusiastically threw himself into this picture of Laura (left).

they assure a painter's material well-being.

Paradoxically, it was just then, when Laura Bellelli finally returned in November, that an enthusiastic Degas began turning out studies for one of his most important oil paintings, and at any rate his biggest: *Family Portrait,* later renamed *The Bellelli Family.*

He did the initial studies for this group portrait in Florence, finished it later in Paris, and probably exhibited it at the Salon (the annual official exhibition of the French Academy) of 1867.

As writer Paul Jamot so aptly put it, *The Bellelli Family* is a picture in which Degas displayed "a taste for domestic drama, a tendency to lay bare the hidden

Working from the many sketches he had brought back with him, Degas finished the large oil painting (see page 30) in the peace and quiet of his Paris atelier. It attracted little notice at the Salon of 1867 and was to languish in a corner of the studio until after his death. It has been acclaimed as the masterpiece of his early years ever since.

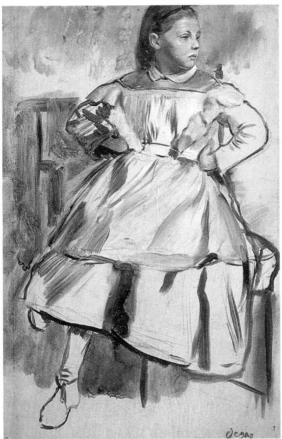

Using a wide range of techniques, Degas built up a set of working sketches that allowed him to bring his large group portrait to fruition: the haughty face of Laura (opposite), gangling Giulia's awkward pose, and the children's winsome faces (left and above).

bitterness between the figures…even when they seem to be presented to us merely as portraits."

Deferring to his father's wishes, Degas finally decided to leave Florence in March 1859 for the return trip to Paris. After a painful separation from his Aunt Laura and a difficult parting with Gustave Moreau, he arrived in Paris and temporarily moved in with his father.

During the next few months, Degas was at loose ends and "down in the dumps," to quote banker Antoine Koenigswarter, a friend of his at the time. The

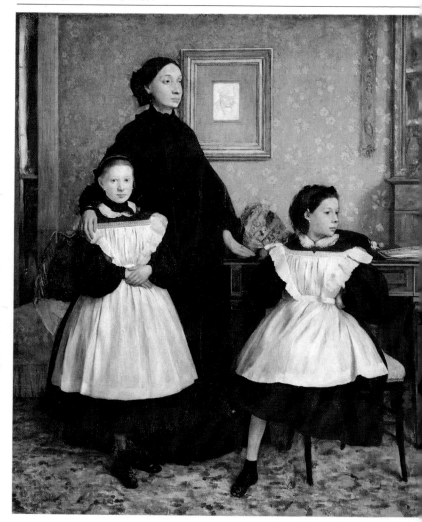

drudgery of looking for a studio—Auguste De Gas had
warned that he would find rents "excessively high"—his
unfulfilled need for Moreau's encouragement, and the
tribulations of reentry into Parisian life after a long stay
abroad made it difficult for him to work.

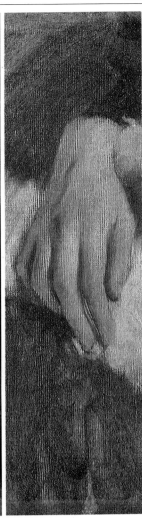

In *Family Portrait,* or *The Bellelli Family,* Degas took a mundane yet poignant case of conjugal incompatibility and gave it the grandeur of a history painting: a woman, still young but suffering from what could be called a persecution complex, waiting for madness and death to claim her; her husband, an embittered, perpetually shiftless exile in a "detestable land"; and their two little girls. Giulia, the one seated lopsidedly at the center of the picture, shows the customary signs of childish unruliness and relieves the grim, oppressive atmosphere. A red-chalk drawing of the recently deceased Hilaire Degas surveys the tense scene from the wall behind them. Mindful that her image is being captured for the ages, the baroness strikes a stiff, detached, self-conscious pose. The indifferent Gennaro has condescended to turn his head for a moment.

Right: Detail of Laura Bellelli's hand.

In the fall, however, the young painter's situation took an appreciable turn for the better. He finally moved into a spacious studio in the part of town where he was born, and in September he was reunited with Gustave Moreau, who had just come home from Italy.

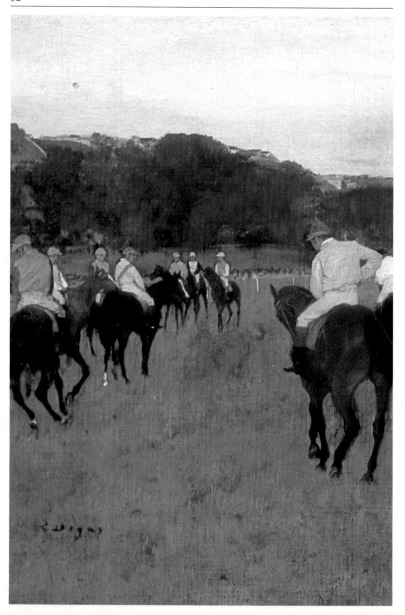

Degas' sojourn in Italy was merely a prelude to his career. Now, in his spacious Paris studio, he could buckle down to creating large-scale pictures intended for the Salon. Although the years 1859–65 were thus primarily given over to diligent work on history paintings, by the end of the decade, Degas focused on subjects from contemporary life.

CHAPTER II
"HE HAS NOT ONLY TALENT, BUT GENIUS"

Contemporary life now surfaced in usually small oil paintings characterized by precise, if not meticulous, handling and smooth, finished "Dutch" brushwork (opposite, a detail from *Racehorses at Longchamp,* 1871). It was also seen in Degas' earliest sculptures, conceived not as works of art in their own right but as modeling exercises that enabled the artist to work out problems of a purely pictorial nature.

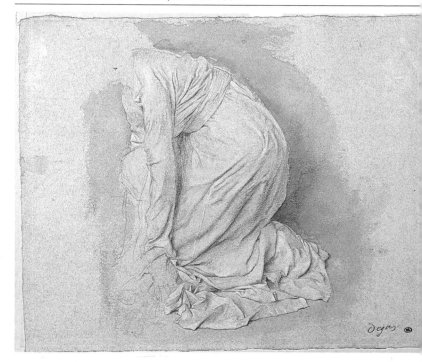

Large-Scale History Paintings

With *The Daughter of Jephthah* (1859–61), his biggest history painting, Degas' aim was to emulate the sweeping works of Delacroix: As he rather vaguely put it, "[I seek] the spirit and love of Mantegna with the verve and coloring of Veronese." Although the picture borrows liberally from 15th- and 16th-century Italian painting, it also shows great originality in its use of violent, jarring, barbaric rhythms to convey the latent paganism of Biblical times.

On the advice of Gustave Moreau, and despite the conflicting view of his father, who felt that Delacroix was on the wrong path, Degas indulged at last in the delights of color, using daringly juxtaposed tones and scattered bursts of vibrant hues across the entire canvas.

The artist took copious notes about and repeatedly copied Assyrian and Persian reliefs, Mogul miniatures, Egyptian paintings, Greek sculpture, and Renaissance paintings (above and opposite above) to prepare for *Semiramis Building Babylon* (opposite).

In contrast with this highly animated scene, *Semiramis Building Babylon* (c. 1860–2) is a controlled, friezelike composition with a muted range of colors that befits the carefully deployed retinue of the queen and her attendants.

The vision of ancient Greece presented in another painting of the same period, *Young Spartans* (c. 1860–2), a scene probably drawn from Plutarch, differs substantially from the ornate paintings popular in France at the time. There is no painstaking archaeological reconstruction, no laborious unearthing of a vanished civilization. Instead, some youngsters with the "common mugs" of Paris street urchins are

In the final version, all of these formal borrowings came together to yield a composition not unlike those of Gustave Moreau.

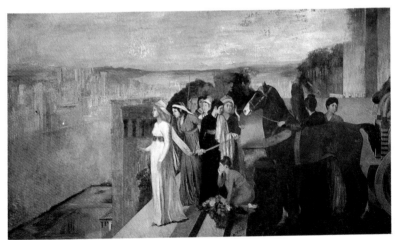

facing off, mysteriously, on a barren expanse of open country devoid of the slightest trace of Hellenism.

In addition, the artist made use of an unconventional technique (essence—oil paint from which the oil has been blotted, then thinned with turpentine—on wove paper mounted on canvas) for his enigmatic *Scene of*

Degas was happy to show visitors his history paintings. His vision of remote antiquity ran counter to the painstaking reconstructions favored by his fellow painters.

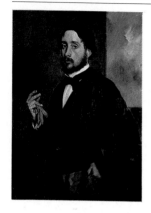

War in the Middle Ages (1865), probably an allegory of the sorrows of the American Civil War and of the particularly cruel treatment the women of New Orleans suffered at the hands of Union soldiers. The magnificent female nudes strewn across this wasteland—fallen, raped, dead—prefigure all the women that Degas depicted years later bathing, drying themselves, combing their hair, dozing, and displaying their bodies unobserved, so they think.

"The Years Are Slipping By"

1859–65: years of misgivings and doubt. Degas was turning out a prodigious amount of work that, to him, seemed never to lead anywhere. To quote René De Gas, who always closely followed his brother's career, "He is working with a vengeance and has only one thing on his mind, his painting. He is so hard at work, he does not take time out for diversion."

In 1863 Auguste De Gas, still impatiently waiting for his son to complete a painting for the Salon, saw his hopes dashed yet again. Two years earlier, he had poked gentle fun at him as he voiced his concern: "Our Raphael is still working but has yet to turn out a finished product; meanwhile, the years are slipping by."

Entirely absorbed in his art, Degas came across as aloof; his gruffness was legendary even then. "What is fermenting in that head is frightening," René stated in 1864, then went on to address the misgivings the entire family shared. "I for one maintain, and am even convinced, that he has not only talent, but genius; only, will he express what he is feeling?"

Degas continued to cultivate his gift for portraiture, at times using himself as a model. The image he presents in *Self-Portrait: Degas Lifting His Hat* (c. 1863, left) is that of a respectable, severe young man, neither dapper nor slovenly, sporting the clothes and emblems of his station (hat, gloves) with casual elegance. His last self-portrait (1865, opposite) shows him with his friend Evariste de Valernes, an undistinguished painter for whom he had great affection. In this moving double portrait, Degas looks ill at ease and has lifted his hand to his chin, a gesture he customarily used to signal reflection or indecisiveness. An X ray of the canvas (below) reveals that in its first state the painter also wore a top hat.

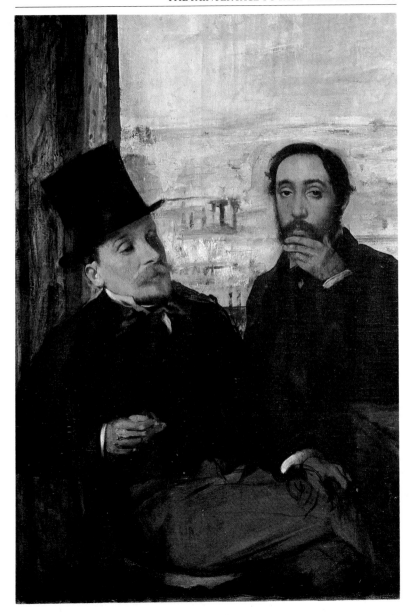

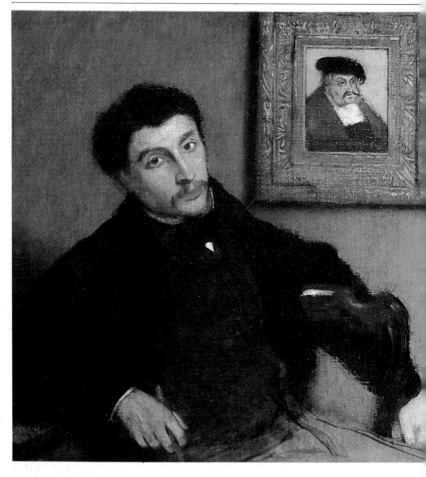

Around 1865 many things started to change. With *Scene of War in the Middle Ages*, Degas was finally allowed to exhibit at the Salon. He continued to do so on a regular basis until 1870. Moreover, he seemed to have given up history painting for good and until the early 1870s devoted himself primarily to portraits— almost half of his output during the twenty-year period between 1853 and 1873 involves portraiture—and,

Products of a comparable social and artistic milieu, Edgar Degas and James Tissot shared common artistic interests, notably in the field of portraiture. By the time Degas painted him (c. 1867–8), Tissot—unlike Degas, who was still a complete unknown—was already basking in success. He owned a townhouse in Paris on what is now Avenue Foch; he had become a popular and famous artist. Degas portrayed him with envy and irony, not at work but as an elegant dandy who is eager to leave a studio in which he is only momentarily seated. The pile of pictures at the right—an outdoor scene, a history painting, an exotic motif—is an allusion to the diversity of Tissot's subjects and techniques. All the same, the eclecticism of Tissot's gifts could not mask the precariousness of his position: Soon he was no longer the innovative painter Degas once knew, but a fashionable artist going downhill. The stern countenance of Lucas Cranach's *Frederick the Wise* seems to sound a cautionary note from the wall behind Tissot.

increasingly, to scenes from contemporary life.

Degas' friendships were in transition, too. His relations with Gustave Moreau cooled very soon after his return from Italy, and it appears he did not associate with Bonnat much past 1863. On the other side of the ledger, new, stronger bonds were forged with painter James Tissot (1836–1902)—who had a comparable cultural background and shared Degas' taste for 15th-

The Racetrack World

In a letter to James Abbott McNeill Whistler (January 1869), Henri Fantin-Latour mentioned seeing "once or twice a week…some small racecourse pictures [by Degas, left] in the Café des Batignolles that people say are quite good." Three years earlier Degas had started doing studies of jockeys and women on the lawn in front of the spectators' stand and peering through field glasses (above).

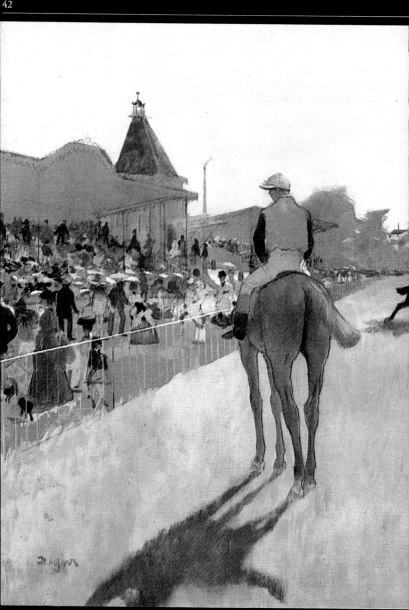

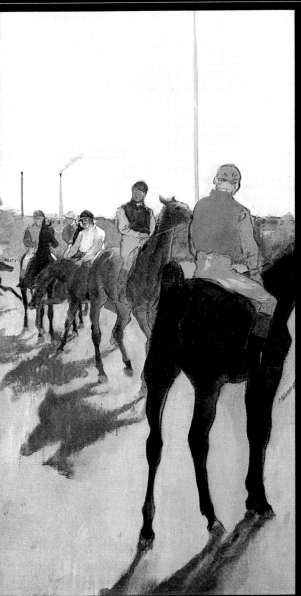

Racehorses Before the Stands

In *Racehorses Before the Stands* (c. 1866–8) some horsemen are walking their mounts at a suburban racetrack, possibly Saint-Ouen, in the unmodulated light of a summer or warm spring day. Unlike Manet, who also started painting racetrack scenes at this time, Degas depicted not a crush of spectators straining against the rail but a delicate patchwork of parasols and pale dresses and suits. The jockey seen from behind (center) echoes the mounted soldier in Jean-Louis-Ernest Meissonier's *Napoleon III at the Battle of Solferino* (1863), a famous painting by an artist Degas praised for his knowledge.

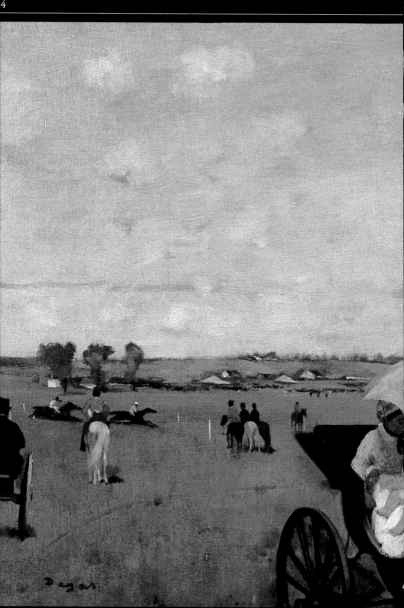

Degas

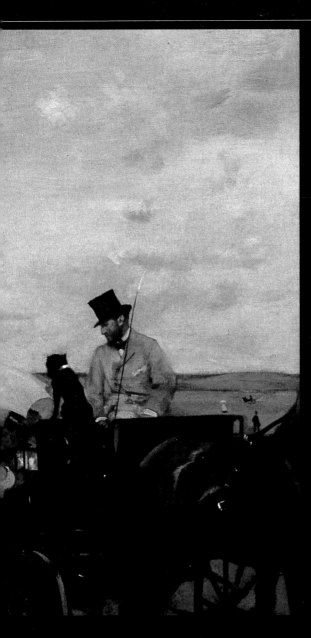

A Country Racecourse

For *At the Races in the Countryside* (1869, detail) Degas chose as his subjects his close friends the Valpinçons. Seated inside the elegant carriage Paul is driving are his wife and a wet nurse with Henri, just a few months old at the time, at her breast. Their destination is the provincial racecourse at Argentan, some nine miles from Ménil-Hubert, the Valpinçon estate. Three horses in the distance are sprinting beneath beautifully luminous skies, although there are no spectators that we can see. This small oil painting, with its precise yet smooth, rich brushwork, belonged to Jean-Baptiste Faure, a famous baritone. Shown at the first Impressionist exhibition in 1874, it was not singled out for comment by anyone except Ernest Chesneau, who gave it high marks for its "exquisite coloring, draftsmanship, lifelike poses, and overall delicacy."

century Italian painters—and, more important, with Edouard Manet (1832–83).

Degas-Manet: A Stormy Friendship

The story goes that they met around 1863 in the Louvre, where Degas was etching a copy of Velázquez' *The Infanta Margarita* directly on a copperplate. Manet was taken aback at the boldness of this artist two years his junior and ventured some advice when it became apparent that the copy was not turning out as planned.

Although it is hard to sift out facts from the fabled association between these two leading figures, the bond between them appears to have been strongest in the late 1870s. Granted, their mutual admiration was marred by stinging comments on both sides. Manet made spiteful remarks about Degas' scant interest in women; Degas took Manet to task for his bourgeois tendencies, his careerism, and the celebrity he had basked in ever since the Salon des Refusés, the exhibition of works rejected by the Salon.

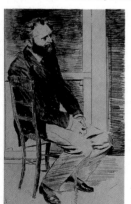

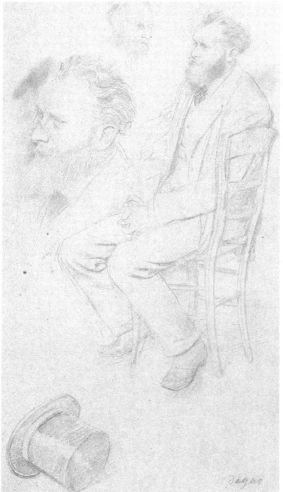

Quite a few of Degas' painter friends posed for him—perhaps for a prospective portrait series—as did a number of musicians a little later on. Without a doubt, the subject who appealed to him most was Edouard Manet, casually posing at the track or in a studio (shown here, left to right, in an etching and wash-and-watercolor, pencil, and chalk drawings). Degas must have been pleased with the calm, pensive likeness of Manet opposite below, *Edouard Manet Seated, Turned to the Right,* because we know of fourteen impressions of the four successive states of this print.

The most famous incident in their conflict-ridden friendship was occasioned by Degas' double portrait of Manet and his wife (c. 1868–9), in which Mme. Manet, an accomplished musician, is shown playing the piano in her Paris drawing room while her husband, sprawled on a sofa, listens. Degas gave this

painting to Manet, who in return presented Degas with one of his still lifes. Some time later Manet mutilated Degas' picture: He cut out what he must have felt was an unflattering likeness of his wife's face.

Years later, around the turn of the century, the dealer A .broise Vollard asked Degas about the incident when he saw the mutilated canvas in the artist's studio.

Vollard: "Who slashed that picture?"

Degas: "Believe it or not, Manet did! He felt that it did not do justice to Mme. Manet. It gave me quite a turn to see it like that at Manet's…. I took my picture with me and left without so much as saying goodbye. When I got home, I took down a little still life he had given me and sent it back to him with a note that read, 'Sir, I am returning your *Plums.*'"

Vollard: "But you and Manet patched things up afterward, didn't you?"

Degas: "How could anyone stay on bad terms with Manet? Only, he had already sold the *Plums.*"

Later on, another dispute between the two artists arose over Degas' portrayal of subjects drawn from contemporary life: Manet maintained that he had begun tackling such themes when Degas was still plugging away at *Semiramis Building Babylon*, if not well before. Degas pointed out, and rightly so, that his interest in racetracks dated from the early 1860s, when he painted several pictures on the subject (although the largest, *The Gentlemen's Race: Before the Start*, from 1862, was substantially reworked twenty years later).

The racetrack theme, which surfaced time and again in Degas' oeuvre into the 1890s, evolved from the many sojourns he made in Normandy with the Valpinçons, starting in 1861. Their estate, Ménil-Hubert, was near the racecourse at Argentan. The rustic setting reminded the painter very palpably of the colored English prints he loved so much. He depicted one of his outings with the Valpinçon family in *At the Races in the Countryside*, a small painting from 1869.

Unlike his friends Tissot, Moreau, and Manet, Degas was, as far as the general public of the early and mid-

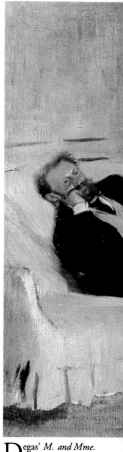

Degas' *M. and Mme. Édouard Manet* (1868–9), with Manet's *Mme. Manet at the Piano* (1867–8) superimposed.

At one point Degas considered, as he put it, "restoring" Mme. Manet after reclaiming the picture Manet had slashed. In the late 1890s or early 1900s he added a strip of prepared canvas to do just that. But the planned restoration was never carried through; perhaps it proved too taxing an exercise because of his failing eyesight. No doubt by then he looked back on Manet's deed with amusement; this brazen "cut-out" may not have displeased him entirely.

1860s was concerned, a complete unknown. He had achieved a degree of celebrity only among other habitués of the Café Guerbois: Manet, Frédéric Bazille, Henri Fantin-Latour, Pierre-Auguste Renoir, and, when they were in Paris, Alfred Sisley, Claude Monet, Paul Cézanne, and Camille Pissarro, among others. Within this select circle of artists he enjoyed an undeniable reputation not only for his manners and tremendous refinement, but for his uncompromising views on art and his already notoriously caustic witticisms.

The Salon, where he exhibited work every year between 1865 and 1870, provided him with his only chance at public exposure. But his attempts repeatedly came to grief. *Scene of War in the Middle Ages* (Salon of 1865) drew praise from no one but Pierre Puvis de Chavannes. Writer Edmond About commented favorably, if tersely, on *The Steeplechase* (Salon of 1866), calling it a "brisk, lively composition." There was no

The subject of *Mlle. Fiocre in the Ballet "La Source"* was a ballerina (photograph, opposite) more famous at the time for her vivaciousness and charm than her dancing ability.

mention of Degas at all in 1867, with the exception of a passing reference to his two family portraits. Emile Zola gave the portrait of Mlle. Fiocre (Salon of 1868) a mixed review. There was more fulsome praise at last for the works he exhibited in 1869, but, all in all, a meager harvest.

Moreover, Degas was selling practically nothing—not that he had to worry about money yet—whereas Tissot had built up a veritable fortune in a few years and Gustave Moreau was represented in the collection of the emperor's cousin, Prince Napoléon.

Degas' portrait *Mlle. Fiocre in the Ballet "La Source"* perfectly illustrates the ambiguity of his position. No doubt Manet had a picture like this one in mind when, quoting art critic Edmond Duranty, he wrote to Fantin-Latour that Degas "was [on his way] to becoming a painter of high life." This very characteristic may in fact explain why so masterful a painting received so little attention from critics. Zola, Castagnary, and Duranty must not have known what to make of this portrait of an artist so far removed from their world, a conspicuous symbol of imperial self-indulgence; while society critics, habitués of the wings, and celebrity hounds saw little in this weary Oriental princess to remind them of the Mlle. Fiocre they had seen on stage.

For his portrait of "one of the great beauties of Paris," Degas decided not to echo the worldly image other artists chose for their likenesses of her. Playing on the ambiguity of time (a break during a ballet rehearsal) and place (a backdrop of boulders that look solid and genuine, a horse drinking from a pool of water, and nothing but a pair of little pink ballet slippers to suggest that we are on the stage of the Paris Opéra), he injected elements of an enchanted world into a realistic setting.

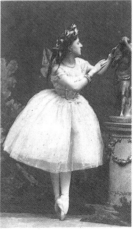

Never Again to Exhibit at the Salon

Clearly, for Degas at least, the institution of the Salon was not the right place for attracting public

notice; later, the breakaway Impressionist exhibitions of the 1870s and 1880s were to prove far more auspicious occasions for this artist, averse to one-man shows.

In 1870 he sent work to the Salon for the last time after publishing an open letter to "the members of the Selection Committee" in the April 12 issue of *Paris-Journal*. In it he proposed a comprehensive set of guidelines to improve the way pictures were displayed: no more than two rows of paintings, a space between them of at least twenty to thirty centimeters, a mixture of drawings and paintings, and the right of every exhibitor to withdraw his or her work after a few days.

Every line in this document hints at the obstacles Degas was up against as a Salon exhibitor. The distinctive, unsettling *Scene of War in the Middle Ages* might not have gone unnoticed, and the masterful portraits of Mlle. Fiocre and Mme. Gaujelin might not have commanded so little attention, had it not been for the confusing practice of hanging pictures row upon densely packed row. And when Degas called for the artist's right to withdraw paintings after several days, he must have been thinking about the difficult time he had when he attempted to remove *The Bellelli Family* from the Salon of 1867 for retouching. At any rate, the year 1870 brought one chapter of Degas' life to a close. Despite the differences he was to have with his colleagues about organizing the Impressionist exhibitions, he had come down on the side that repudiated the Salon establishment. There was no turning back now.

A Privileged Work Environment, and the Beginnings of Recognition at Last

Replete with family events—the artist's two sisters got married, while René moved to New Orleans at Edgar's urging and took his first cousin as his bride—the 1860s were happy years for the artist, engrossed in his evolving oeuvre and unencumbered by the repeated tribulations, if not disasters, that marred future phases of his career. Were it not for his persistent inability to

Sulking (c. 1869–71) was, and still is, an intentionally ambiguous picture. Someone has interrupted what appears to have been a tense discussion between a man and a woman whose exact relationship is unknown. Momentarily motionless, they are simply waiting for the indiscreet intruder to depart.

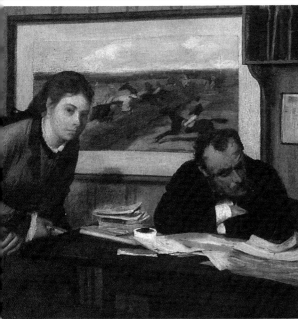

Degas probably painted his two younger cousins Giovanna and Giulia Bellelli (below, painting and details) in June 1865. He captured them at an age when they were no longer the boisterous little girls of *The Bellelli Family,* but had not yet become refined young ladies.

find his place in the public eye— not that that ever dampened his enthusiasm for work—one might characterize this period as serene.

Degas still had no financial cares, and the family fortune—to be more exact, his father's affluence—afforded him a comfortable life unhampered by the need to sell his art. After 1868–9 there were new developments: He started to gain recognition outside his small circle of acquaintances and seemed to become somewhat more actively involved in the dissemination of his work. In 1869 his brother Achille wrote to the Musson family in New Orleans that, during a trip to Brussels, Edgar had shown his work in the gallery—"one of the best-known in Europe"—of a royal minister by the name of Van

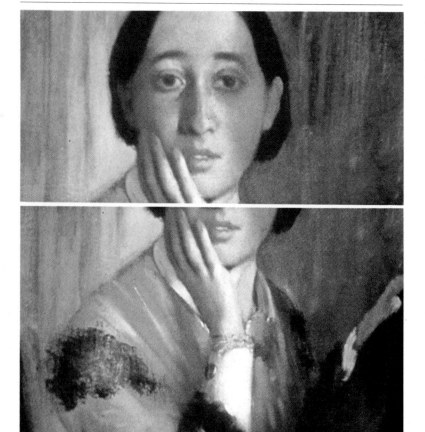

Praet and that it had "given him some pleasure…and some confidence at last in himself and in this gift he really has." During this sojourn in Belgium, the well-known dealer Arthur Stevens is said to have even

In this 1865 painting Thérèse De Gas-Morbilli, who had just lost a child, is merely her husband's shadow.

approached him about a contract "at twelve thousand francs a year." Like Manet, Degas was feeling out the English art market as an outlet for his "wares."

Nothing better illustrates Degas' curious predicament than the exchange of letters during 1869 in which the Morisots, a cultured family of painting enthusiasts, discuss the sittings he required of one daughter, Yves (Mme. Théodore Gobillard), to do studies for her portrait. The family scrutinized Degas and formed very definite opinions about him. Another daughter, Berthe, who felt little affinity with him at the time, pronounced the first sketch he had done of her sister "mediocre," but made up for it later when she described the pastel portrait of Yves (Salon of 1870) as a masterpiece.

In the eyes of this respectable but bohemian family, Degas came across as a "character," dropping in when he had a minute and when the Morisots

Open-eyed and anxious, she is reaching out for his shoulder. Edmondo Morbilli has the elegant bearing of a Renaissance nobleman.

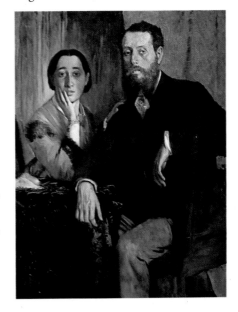

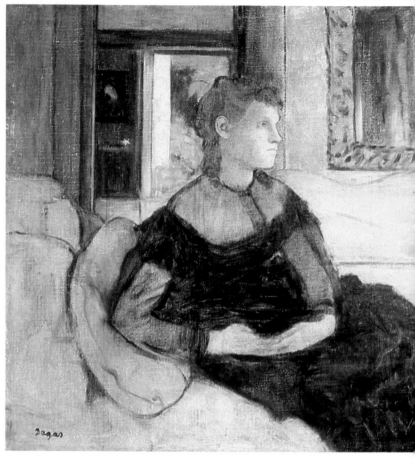

could receive him. He did not work in the monastic hush of the studio but amid the everyday hustle and bustle of a populous household. "He asked me for an hour or two during the day," wrote Mme. Morisot in late June. "He came for lunch and stayed the entire day. He seemed pleased with what he was doing and sorry to part with it. Working really is easy for him, because it all happened amid the social calls…that never let up during those two days." The month before, Berthe had

During a brief stay in Paris in the spring of 1869, Degas made a portrait of Berthe Morisot's older sister, Yves (Mme. Théodore Gobillard).

mentioned his "chattering away the whole time he worked" on the first drawing.

Yet, the same man who amid constant commotion could turn out study after probing study for a difficult portrait spent years on certain pictures without ever really finishing them. The hallmarks of Degas' art making were established from the outset: the perennial mixture of obvious facility and dissatisfaction, the perpetual doubt, an irrepressible need occasionally to return to pictures he had consigned to a corner of his studio, a dogged determination always to forge ahead and come up with fresh and unusual variations on often identical themes, the range of which was to narrow in the years to come.

This sedentary, work-oriented existence offers little in the way of incident to report, especially as the artist was circumspect about his private life. A passing reference in a notebook (in 1856, having been spurned by a young woman whom he may have tried to take advantage of, he simply mentioned the intensity of his love for her) or in a letter (in 1859 he confided his passion and wedding plans to his aunt Laura Bellelli) and a few tidbits of spiteful gossip ("He is incapable of loving a woman, of even telling her he does," Manet confided to Berthe Morisot) leave much about his love life unanswered.

A painting such as *Interior,* also called *The Rape,* says more than any commentary could about the shadowy nature of his sexual and emotional life. In a young woman's modest room stands a man who has no business being there. He has already staked out his

N ew faces started appearing in Degas' circle of friends in the late 1860s. He was now a regular at the Café Guerbois and found himself routinely running into Manet; through him he met, and soon won over, the Morisot clan.

B erthe Morisot, as Manet portrayed her in *The Balcony* (top, detail), and her studio (above).

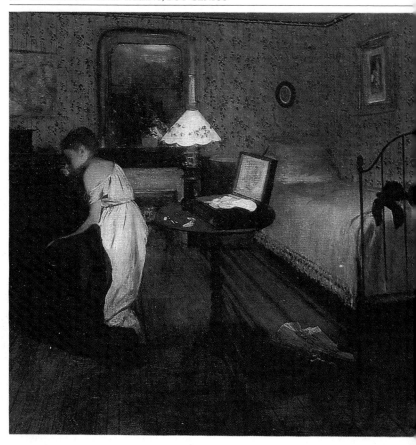

territory: His personal effects are scattered throughout the space (top hat on the chest of drawers, overcoat on the bed). The woman is slumped, partially disrobed, in a chair. At the very center of the picture, in the glare of lamplight, can be seen the sharp points of a pair of scissors and some white fabric spilling out from a box, opened to reveal the pink lining within. Not since *Broken Pitcher*—only without Jean-Baptiste Greuze's pretentiousness—had the loss of virginity been so graphically symbolized.

Degas did not give the picture known as *Interior*, or *The Rape*, its dual title; he simply—and enigmatically—referred to it as "my genre painting." According to one (unlikely) interpretation, it illustrates a passage from Émile Zola's recently published novel, *Thérèse Raquin*.

The Franco-Prussian War and the Paris Commune

The Franco-Prussian War (1870–1) and the Paris Commune, the violence-ridden opposition government that followed, interrupted the flow of his career. In September 1870 Degas enlisted in the National Guard, as did Manet. Early in October he was posted to Bastion 12, a fortification north of Paris under the command of Henri Rouart, a former schoolmate from Louis-le-Grand whom he now befriended anew. Degas and Manet engaged in often heated discussions about the best strategy for dealing with the occupying forces. "They nearly came to blows," reports Berthe Morisot's mother, "arguing over the use of the National Guard and its methods of defense, although each of them was willing to lay down his life to save the country…. M. de Gas has joined the artillery and, to hear him tell it, has yet to hear a gun go off. He is listening for that sound as he wants to know whether he can withstand the blast of the cannons."

The painting's source and meaning may not be obvious, but its pictorial aspirations are. "Work hard at evening effects, lamplight, candlelight, and so forth," noted Degas. "The intriguing thing is not always to show the source of light but its effect."

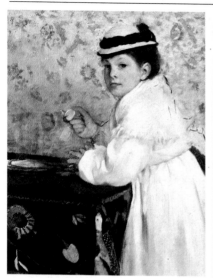

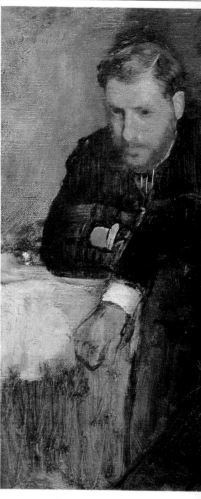

However, these sometimes frivolous arguments aside, war brought its unavoidable share of real tragedy: the death, at age twenty-nine, of painter Frédéric Bazille, slain near Orléans; Degas' friend the sculptor Joseph Cuvelier also died, which led to an estrangement from Tissot because the latter had returned with a drawing of the artist dying.

It also brought the joy of new friendships outside his usual element: Witness the touching triple portrait *Jeantaud, Linet, and Lainé* (1871), which depicts three former comrades-in-arms at the end of a veterans' dinner. The atmosphere of casual elegance is worlds away from the hardships of the siege of Paris, during which he had met them.

During the Commune Degas was not in Paris but in Normandy with the Valpinçons. It was here that he probably painted the beguiling portrait of their

The browns, blacks, and dark reds of *Jeantaud, Linet, and Lainé* (above) help convey a mood of world-weary, wistful camaraderie at the end of a dinner party.

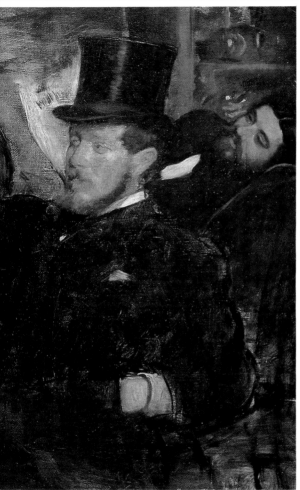

Years after the fact, Hortense Valpinçon recalled the circumstances surrounding Degas' painting a portrait of her (1871, left). "It was rather a spur-of-the-moment idea, and materials were hard to come by. Degas had nothing readily available in the way of canvas. He was given a piece of mattress ticking from the bottom of a linen closet in the château.... The painter told the little girl to behave herself but still had some difficulty drawing the firm yet supple contour of her cheek. He had been unwise enough to put sections of apple in his model's hands. One does not ask a little girl to pose for several hours with an apple in her hand. What is there left for her to do but eat it? So, she grimaced, her cheeks kept changing shape, her mouth was taut one moment and relaxed the next. The painter's exasperation led to rage, then scoldings and interruptions in his work. At other times, if the child was good and Degas was satisfied with what he had done, the session would end in merriment."

daughter, Hortense. We know—again through Mme. Morisot—that after his return to Paris on 1 June Degas was vehemently opposed to the repression of the Communards. "Tiburce [Morisot] has met two Communards, just when they are all being executed: Manet and Degas! Even now they are denouncing the drastic measures that have been taken to repress them."

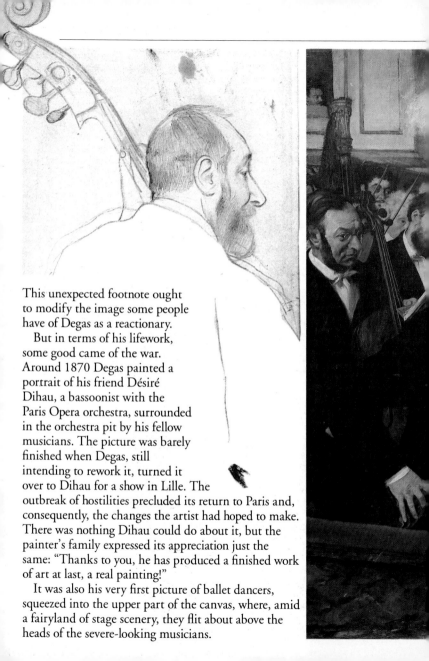

This unexpected footnote ought
to modify the image some people
have of Degas as a reactionary.

But in terms of his lifework,
some good came of the war.
Around 1870 Degas painted a
portrait of his friend Désiré
Dihau, a bassoonist with the
Paris Opera orchestra, surrounded
in the orchestra pit by his fellow
musicians. The picture was barely
finished when Degas, still
intending to rework it, turned it
over to Dihau for a show in Lille. The
outbreak of hostilities precluded its return to Paris and,
consequently, the changes the artist had hoped to make.
There was nothing Dihau could do about it, but the
painter's family expressed its appreciation just the
same: "Thanks to you, he has produced a finished work
of art at last, a real painting!"

It was also his very first picture of ballet dancers,
squeezed into the upper part of the canvas, where, amid
a fairyland of stage scenery, they flit about above the
heads of the severe-looking musicians.

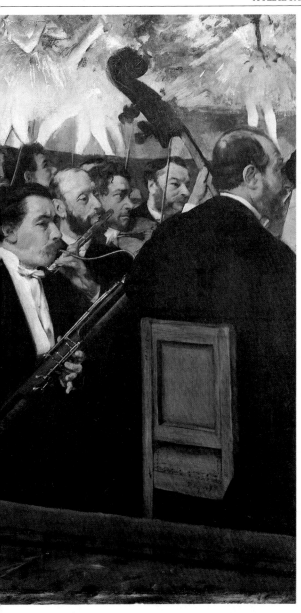

The Orchestra of the Opéra (c. 1870) is a portrait of Désiré Dihau, an Opéra bassoonist, shown playing his instrument. The orchestra is rather eclectic because Degas, rearranging the traditional configuration in the pit, contrived it out of the assembled portraits of real-life musicians and obscure friends. There is particular emphasis on the comically shaped musical instruments, the strange crush of faces, the fragments of portraits that emerge only to be besieged by bows and cut off by the artful point of view. The multicolored tutus of headless ballerinas can be seen bobbing above the heads of the musicians dressed in black and white.

Opposite: *Gouffé, Double Bass,* c. 1870, a study for *The Orchestra of the Opéra.*

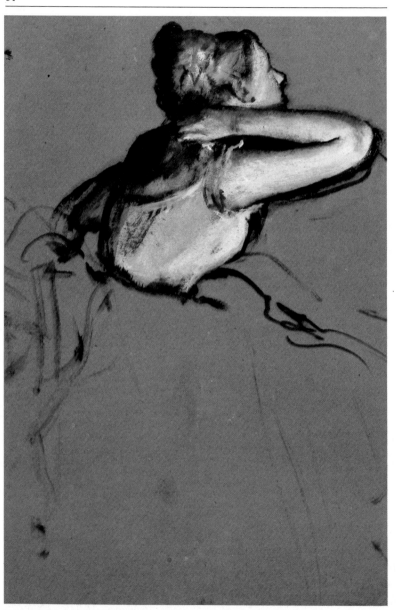

❝ The break is over, the music grinds up again, the torture of the limbs resumes, and in these pictures where the figures are often cut off by the frame, as in certain Japanese images, the exercises speed up, legs rise rhythmically, hands clutch the barres running along the wall, toe shoes frantically thump the floor, and lips smile automatically....

CHAPTER III
THE PAINTER OF
WOMEN

Two 1873 dancers: *Seated Dancer in Profile* (opposite) and *Dancer with Arms Behind Her Head* (right).

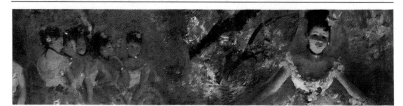

"When your eyes are trained on these leaping figures, the illusion becomes so complete that they all come to life and gasp for breath, and you can almost hear the shouts of the dancing mistress piercing the shrill din of the violin—'Heels forward, hips back, hold up your wrists, now crack your joints'—while at that final command, the *grand développé* gets under way, and uplifted legs, lifting puffed tutus with them, come to rest, strained, on the highest barre" (from Joris-Karl Huysmans' review of Degas' pictures at the fifth Impressionist exhibition in 1880).

From the Auditorium to the Wings

The Orchestra of the Opéra marked a turning point in the painter's oeuvre. Moving beyond the portrait of Mlle. Fiocre, the subjects he would return to time and again emerged: the dance and the stage. It is difficult to say precisely when Degas began to haunt the theater, both out front and in the wings. Although we know which performances he attended between 1885 and 1892, information about earlier years is very sketchy. He went to the old opera house on Rue Le Peletier (and, starting in 1875, the Palais Garnier), but not as a subscriber, and at the time did not enjoy the signal privilege of being allowed backstage.

The paintings themselves add little more in the way of precise details because the scenes Degas depicted

Degas painted these *Orchestra Musicians* (below, details above and opposite below) in 1870–1. He later added a strip of canvas to the upper edge to accentuate what is happening onstage. By superimposing two worlds—the musicians in their gloomy underworld, the dancers in their Eden of painted backdrops— he was able to bring out differences in scale (the men's massive backs, the dancers' slight builds), lighting, and brushwork.

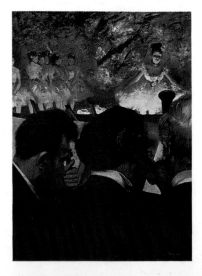

were based on what he saw in his mind's eye, not in actual stage performances. He had to ask for permission to sit in on a dance examination at the Opéra: "I have done so many of these dance examinations without having seen them that I am a little ashamed of it," he confessed. Starting in the early 1870s, Degas turned out an increasing number of ballet pictures, some of dancers on stage, but more of classes. They proved an immediate success—hence, their recurrence.

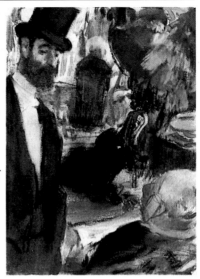

Why this subject? Associating with members of the Opéra orchestra (the bassoonist Dihau, the flutist Altès, the cellist Pilet), as well as with fans (the engraver and costume designer Ludovic Lepic and the writer Ludovic Halévy) gave Degas a clearer understanding of the special world he had only glimpsed through Eugénie Fiocre.

Using monotype often reworked with pastel (above), Degas illustrated three short stories by his friend Ludovic Halévy.

In May 1870 Halévy published *Madame Cardinal*, the first in a series of short stories recounting the humorous adventures of a two young dancers from the Opéra, Pauline and Virginie Cardinal. In November 1871, when Degas was probably working on *Dance*

Class, Halévy followed up with *Monsieur Cardinal,* which opens with a description of the corps de ballet making its entrance on stage. Degas was not yet illustrating Halévy's stories, though he did so later on; however, he surely profited from the writer's advice at a time when the painter was for the most part unfamiliar with the world backstage. This particular *Dance Class* shows the obscure Joséphine Gaujelin (whose portrait he had previously painted) about to start her exercises. In *Dance Class at the Opéra* (from 1872), he painted the well-known figure of ballet master Louis Mérante.

Both paintings were bought in 1872 by dealer Paul Durand-Ruel, whose gallery was featuring the work of Barbizon School artists at the time. These purchases marked the beginning of a long, if not particularly friendly, partnership between Degas and the man who went on to promote and market Impressionist artists in the 1870s. It also signaled Degas' entry into the art business.

Degas and the Art Dealers

Unlike Monet, Renoir, or Pissarro, Degas sold work frequently but not steadily, delivering recently finished "wares" or "goods" (his own words) to a dealer with whom he had rather a cool business relationship at best. On occasion, he parted with older pictures, too. The fact that he let Durand-Ruel have one of his very first paintings, *Roman Beggar Woman* (1857), in 1897 underscores the importance the mature Degas still attached to his early works. There are many such examples. Degas would turn out "goods" specifically aimed at the art market, or once in a while authorize a sale of pictures from various periods with Durand-Ruel acting primarily as banker, a role that would later expand when Degas spent large sums of money to add to his own painting collection.

The introduction of Degas' artwork into the market and the exhibitions in which he took part—in particular, the ones Durand-Ruel was organizing in London on a regular basis—led to a substantial change

At the center of *Dance Class* (1871), the first in a famous series, Joséphine Gaujelin, center, awaits the signal from the ballet master's violin.

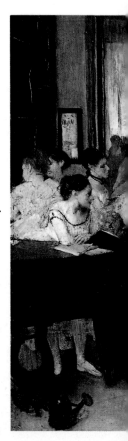

in the painter's oeuvre. His art was being disseminated, a small network of Degas enthusiasts and collectors was in the making, and the artist paid more attention to what we would nowadays call career choices.

In the 1870s Durand-Ruel suffered a setback that forced him to temporarily withdraw his support of the Impressionists. Deprived of this source of income, Degas could still turn to Charles W. Deschamps, a London dealer, and a handful of private collectors, including the famous baritone Jean-Baptiste Faure.

Having limbered up at the barre, the dancers are about to begin their exercises in the middle of the floor in a decrepit practice room: "jetés, balancés, pirouettes, gargouillades, entrechats, fouettés, ronds de jambes, assemblées, pointes, parcours, petits temps…"

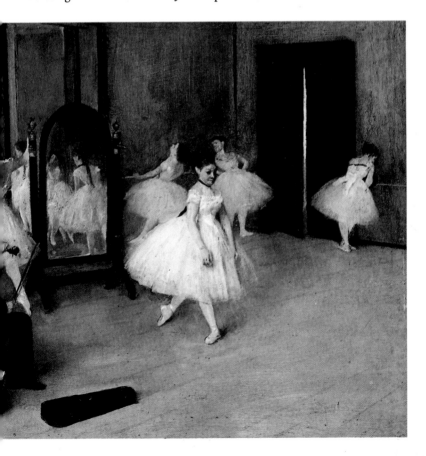

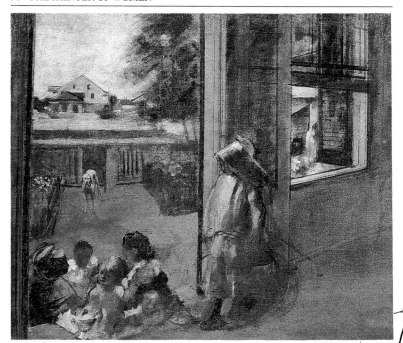

An American Adventure

All of this was bound to change Degas, who from then on seemed "seasoned… more serious, more calm," as his brother René noted in the summer of 1872 during a stay in Paris.

Settling into bachelorhood—"he has a good cook and a charming bachelor flat," René wrote his family in New Orleans—Edgar worked during the day and at night enjoyed going "to the Champs-Elysées and from there to the *café chantant* to hear foolish ditties," or "dining in the country and visiting the never-to-be-forgotten sites of the siege."

During the summer of 1872 René finally induced his brother to go to New Orleans

and spend some time with his mother's side of the family. "Get ready to welcome the Gr-r-reat Artist in a manner befitting him," announced René half-proudly, half-sarcastically, adding that "he asks not to be met at the station with the Bruno Band, militia, firemen, clergymen, etc." After much vacillation, the "great artist" decided to set sail for America that October.

Throughout his stay in New Orleans, Degas was astonished by the things he saw. With René, "who is a local," as his guide, he took in everything: the sleeping compartments in the trains, the "various shades" of the black women who minded the children, the "white houses with columns of fluted wood," the "steamboats with twin funnels," and the "contrast between the bustle and efficiency of the offices and this vast dark animal strength."

Instead of being inspired to turn all these new impressions into a variety of intense pictorial transcriptions— which is what one would have expected—Degas pulled back at once and began longing for the cozy Parisian world he had just left behind: "All I want now is to see my little corner of the world and burrow there diligently." He likened himself to philosopher Jean-Jacques Rousseau, scrutinizing everything, starting "projects that would take ten years to finish" only to drop them "ten minutes later without regret." Life seemed bleak: a brief attack of dysentery, the sweltering heat, the warm "killing" winds, the "genuinely distressing" dearth of opera, and the constant intrusions of a large, importunate family.

From the day he arrived in New Orleans, Degas found himself obliged to paint portraits of family members. Opposite: *Children on a Doorstep (New Orleans).* Opposite below: A drawing from a notebook.

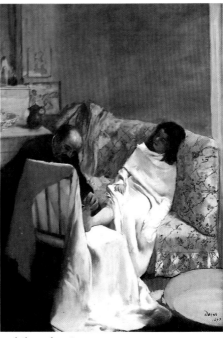

Essence, the medium used for *The Pedicure* (1873)—once described as primarily a "portrait of a sheet and a dressing gown"—creates soft matte tones and abets the subtle interplay of transparent and opaque effects.

From the very start, Edgar was beset by relatives wanting to see what the young painter from Paris could do. Bowing to popular demand, he resigned himself to doing "family pictures." One after another, his relatives posed for him: his sister-in-law Estelle Musson (René's wife), his cousin Désirée, his Louisiana relations' boisterous brood. He derived little from it and complained, as he had in Florence fifteen years earlier, of how "bored" he was with portrait painting. He notified his friends back in Paris that he would be coming home very soon.

However, in February 1873, even after his travel plans were made, he told his friend Tissot, in London, that he had buckled down to "a rather forceful picture" intended for sale in England. This painting, the famous *Portraits in an Office (New Orleans)*, is more commonly known as *The Cotton Market at New Orleans*. In it we see fourteen individuals in the office of Degas' uncle, Michel Musson, all of them busy with various aspects of the cotton business, except for the painter's two brothers, who appear to be simply loitering. In his letters Degas stressed cotton's omnipresence in the Louisiana city: "People do nothing here, it is in the very climate, except cotton: They live for cotton and from cotton"—an observation borne out by the dazzling whiteness of samples spread out on the table like a miniature sea. This "clear and clean" picture of a crowded yet orderly office effectively conveys his vision of America as a faraway land of tranquil prosperity. Except for the variation on this subject now in the Fogg Art Museum at Harvard, this is the only painting Degas is known to have brought back from America. Others *(Woman with a Vase of Flowers, The Song Rehearsal)*, though possibly begun there, were probably finished in Paris.

Settling in for a Long Spell of Solitude

The period of extended stays in distant places was over. From now until his death, Degas was to lead a sedentary life, leaving Paris only for routine

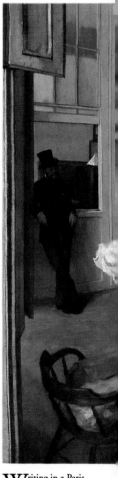

Writing in a Paris newspaper, Albert Wolff lambasted the "pontiff of the sect of intransigent Impressionists" (as another critic mockingly dubbed Degas) for his *Portraits in an Office (New Orleans)*, 1873.

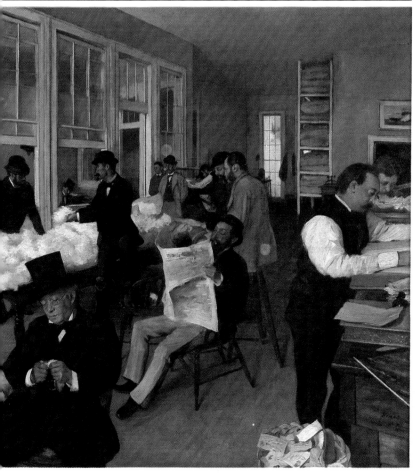

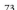

summertime sojourns in Normandy or, later, at the spas of southwestern France, and an occasional trip to Naples to try to iron out the never-ending financial problems he had with his father's side of the family.

The 1870s witnessed a flurry of activity in all areas—the organizing of Impressionist exhibitions, a highly diverse artistic output, numerous technical innovations—but were marred by family misfortunes,

"Try and reason with Monsieur Degas; tell him that there are qualities in art known as drawing, color, execution, control, and he will laugh in your face and call you a reactionary."

Albert Wolff

which Degas had never had to contend with previously.

On 23 February 1874 Auguste De Gas passed away in Naples, and the death of the man he would never call anything but his "dear papa" had a profound effect on the painter. Over the bed in his room he kept a small picture he had painted two or three years earlier, showing Auguste, alert but bent with age, listening to Lorenzo Pagans sing a Spanish song. His uncle Achille died in February 1875, but the estate was not to be settled until 1909.

The sorry state in which Auguste De Gas had left the family firm, the impossibility of dividing the property in Naples, and the debts René De Gas had incurred saddled the artist with his first financial burdens and forced him to concentrate more on selling his work, on the business end of his career.

Then, yet another stroke of hard luck: In 1875, "hot-headed Achille," Degas' good-looking, somewhat conceited brother, shot and wounded his former mistress' husband twice after the man had assaulted him at the Paris Stock Exchange. Scandal. The inevitable trial.

Now in his forties, Degas always seemed to friends to be anxious, insecure, perpetually "thirsting for order," but never quite managing to settle down. "Living alone, without any family, is really too hard," he wrote his friend Mme. Léontine De Nittis in 1877. "I never would have suspected it would cause me so much distress. So here I am, growing old, in poor health, and almost penniless. I've made a thorough mess of my life on this earth."

Curiously enough, Degas never painted a portrait of his father, Auguste De Gas, by himself. He is shown here shortly before his death (c. 1871–2), but behind Lorenzo Pagans, a Spanish tenor.

In the 1890s, Degas showed the small painting to Paul Poujaud, a friend of his: "I am sure he did not show me the Pagans as a memento of his father, whom I did not know and whom he had never mentioned to me, but as one of his finished works, and one which he prized."

Degas in the Eye of the Impressionist Storm

The outstanding events of these years were a series of Impressionist exhibitions which, despite the sharp criticism they often drew, kept Degas' name in the public eye. He was instrumental in organizing each of them from the day in December 1873 when he joined Monet, Pissarro, Sisley, Morisot, Cézanne, and several others in forming the "Société Anonyme des Artistes Peintres, Sculpteurs, Graveurs, etc...." Its objectives: to exhibit freely and without selection committees, to sell the works exhibited, and to publish an art journal (which never materialized).

At the first group show in the spring of 1874, Degas exhibited ten pictures and, some unfavorable reviews notwithstanding, drew a goodly amount of praise. The exhibition as a whole, however, was a failure: Savage attacks in the press, poor attendance, and few sales led to the demise of the artists' cooperative.

They tried again two years later, this time at the Durand-Ruel Gallery, 11 Rue Le Peletier. The catalogue listed twenty-two works by Degas. Once again, the press was divided; but even to his detractors, Degas was looking more and more like a group leader, a standout. Subsequent exhibitions in 1877, 1879, and 1880 all triggered differently worded variations on the same, and by then rather tedious, criticism; but increasingly frequent acclaim testified to a newfound appreciation of Degas' art and, even among his opponents, a growing awareness of his special place within the group.

Degas may have had his diehard detractors, but he

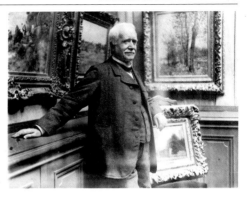

SOCIÉTÉ ANONYME
DES ARTISTES PEINTRES, SCULPTEURS, GRAVEURS, ETC.

PREMIÈRE

EXPOSITION
1874
35, Boulevard des Capucines, 35

CATALOGUE

Prix : 50 centimes

L'Exposition est ouverte du 15 avril au 15 mai 1874,
de 10 heures du matin à 6 h. du soir et de 8 h. à 10 heures du soir.
PRIX D'ENTRÉE : 1 FRANC

PARIS
IMPRIMERIE ALCAN-LÉVY
61, RUE DE LAFAYETTE

1874

Paul Durand-Ruel (top).

"We do not know why Monsieur Degas has included himself in the Impressionist fold. He has a distinct personality and stands apart in this group of self-styled innovators."
Critic Paul Mantz

had his supporters, too. In 1880, Joris-Karl
Huysmans, who had already had occasion to sing
his praises in print, devoted a long, enthusiastic
article to him in *L'Art Moderne.*
A few years earlier Edmond
de Goncourt—not one of
Degas' most impassioned
defenders—thought him distinctive
enough to warrant special mention in his
Journal: "An unconventional fellow...sickly,
neurasthenic, so plagued by eye trouble that
he is afraid of losing his sight; yet, for these very
reasons, a highly sensitive person." In 1876 poet
Stéphane Mallarmé, a future friend, made some
especially glowing remarks about him in an article
published in London.

The 1870s yielded a particularly rich bounty
of varied and, at times, technically complex
works on numerous subjects that quite
often the artist tackled for
the very first time. Although
there tended to be fewer
of the portraits that had
figured so prominently in
previous decades, Degas
produced more pictures
of ballet dancers. He also
continued to work on his
racetrack scenes, depicted
his first laundresses, and
started to show interest in
café-concerts and brothels.

The mediums he used were
as diverse as his subjects: oil paint, of course,
and the gamut of drawing mediums, but also pastel,
which was assuming ever-increasing importance in his
oeuvre, and monotype, which Degas claimed to have
invented. In addition to being closely connected with
18th-century art—with which he had been familiar
since childhood—pastel proved advantageous for a

Detail of *Women on
the Terrace of a
Café in the Evening:*
Alluding to a tightfisted
client, a prostitute
clicks her fingernail
against her teeth.

number of reasons. Dry (allowing him to work more spontaneously than he could in oils) and opaque (making it easier for him to make changes), it was ideally suited to an artist who worked quickly but retouched the same picture over and over again. Also, the evanescent quality of pastel, that "powder of a butterfly's wings," made it a wonderfully effective medium for conveying the elusiveness of subjects like café-concert performers belting out songs beneath clumps of foliage,

Opposite above: *Dancer Adjusting Her Stocking* (c. 1880–5). Below: *Seated Dancer,* c. 1878.

or Parisian girls who metamorphosed on stage into ethereal creatures in multicolored tutus, an occasional lapse into coarseness the only vestige of their former chrysalis.

Painter of Dancers, "Faraway, Made-Up" Creatures

The unremitting quest for technical innovation and this need to utilize a gamut of mediums went hand in hand with Degas' renewed interest in dancers.

If there was a point at which Degas became the "painter of dancers," it was now, when he turned out a large number of dance scenes using a wide range of techniques and supports of

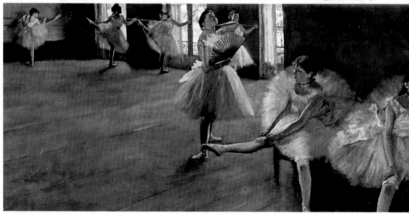

various shapes and sizes. In his earliest pictures of onstage dancers, Degas took the physical distance between the ethereal ballerinas and the somber musicians in the pit or the stern subscribers in the first row of the orchestra and used it to accentuate the contrast between the Eden of the stage, in which these "faraway, made-up" creatures bobbed about, and gloomy Hades. Now he followed them behind the painted backdrops and into cheerless

The unusually elongated formats Degas often favored for dance and racetrack scenes allowed him to contrast inventively clustered figures with broad expanses of empty space. Above: *The Dancing Lesson*, c. 1880.

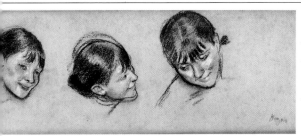

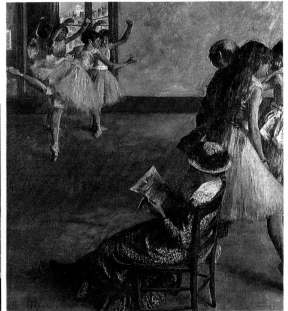

Painted for Mary Cassatt's brother, Alexander, *The Dance Class* (1881, below left) was substantially reworked prior to its long-deferred completion. Although the extent of the changes, some visible to the naked eye, still attests to the artist's reluctance to consider it a finished product, it proved to be one of his most startling compositions. He skewed the position of the mother reading *Le Petit Journal* in the foreground; clustered a knot of dancers, arms extended as if from some multi-limbed Hindu goddess, in front of a Parisian cityscape of gray facades, chimneys, and white smoke (upper left); and relegated to the far right two other dancers with wide pink and green bows and a ballet master almost completely hidden from view. His peculiar-looking head, with its bald pate and protuberant ears, seems to be attached to that of the long-haired girl, and the resulting composite is reminiscent of a two-headed deity.

Opposite above: *Study of a Violinist.*

Above: *Three Studies of a Dancer's Head* (c. 1879–80).

rehearsal rooms, into some nook where they might be chatting with a patron, warming themselves, or stretching.

The observer was not cruel, as some alleged, only sharp-eyed and uncompromising. In picture after picture, Degas repeated the "common mugs" of dancers—usually no more than little girls—the vigilant mothers who acted as their chaperones, the ticket holders in dark suits, and the swirl of tutus and colored

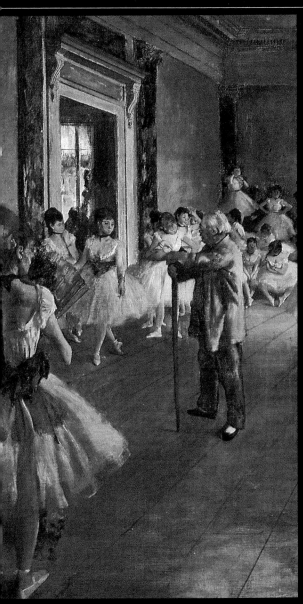

**The Dance Class
(Musée d'Orsay
version, detail)**

Begun in 1873, shortly before the Metropolitan Museum version (see next page), but completed later (1875 or early 1876), *The Dance Class* depicts a lesson under the direction of Jules Perrot, a famous dancer and choreographer. The ballet master Degas originally intended to portray was younger and had his back turned completely to the onlooker; the artist decided instead on the well-known and beloved figure of Perrot, which he studied in a beautiful 1875 essence sketch (far left). With this large-scale composition, in which more than twenty figures are strewn across the stately rehearsal hall, Degas moved away from the small formats he had initially favored for his dance scenes. To avoid a feeling of congestion, a swath of empty space has been contrived between Perrot and the surrounding dancers, who are scratching themselves, stretching, adjusting a ribbon, and chatting with their mothers at the far end of the room. A dancer is poised to begin her exercises in the middle of the floor under the master's watchful eye, and a little dog has been startled by its reflection in the shiny surface of a watering can.

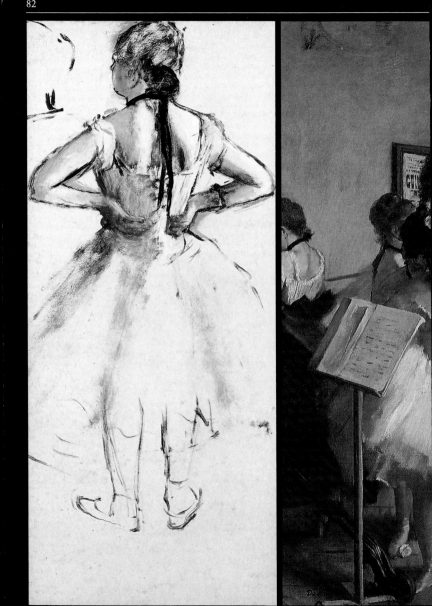

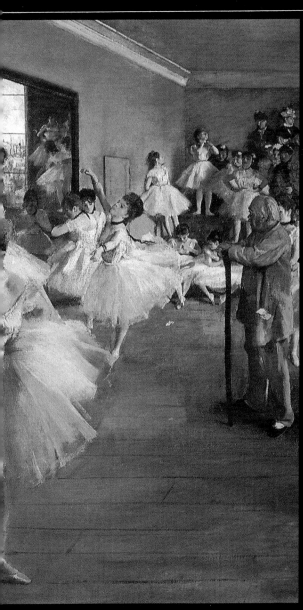

The Dance Class (Metropolitan Museum version)

*T*he Dance Class (1874) was the first of six compositions Jean-Baptiste Faure commissioned Degas to paint. In his *Mémoires,* Durand-Ruel tells of how the famous baritone, who also collected works by Delacroix and Corot, became interested in the Impressionists. "Degas… started to deliver a series of pastels and paintings that did not spark much interest at the time and which for many years I had a great deal of trouble selling in spite of their very low prices. Faure, a longtime acquaintance of mine…bought some of these pictures from me; I later bought them back." In March 1874, acting on Degas' behalf, Faure agreed to buy some pictures that the artist was not pleased with and planned to retouch. In exchange, Degas promised him four large paintings, only two of which were delivered in 1876. Degas eventually made good on the other two, but only after Faure started legal proceedings against him.

*O*pposite: *Standing Dancer Seen from Behind* (c. 1873, detail).

*O*verleaf: *Dance Class at the Opéra* (1872).

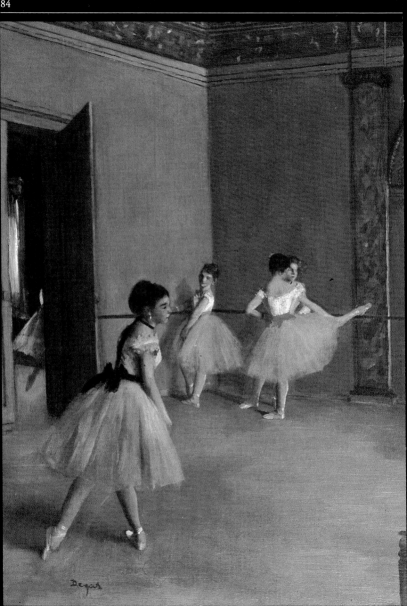

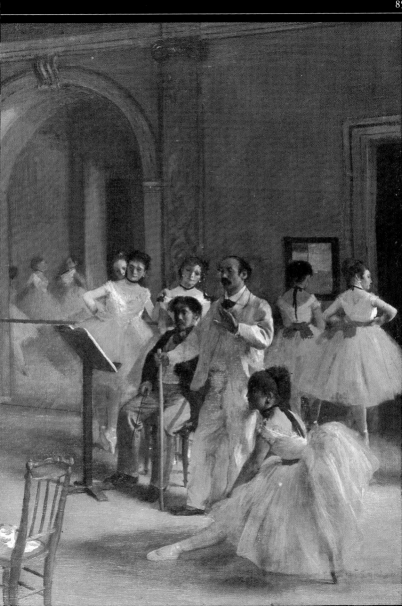

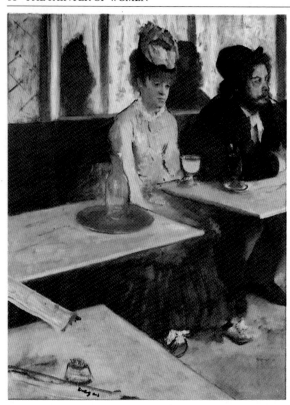

Degas asked two of his friends, engraver Marcellin Desboutin and actress Ellen Andrée, to pose for this genre scene (left). Nearly a half-century later, Andrée dimly recalled having sat "for a café scene." "I am sitting in front of an absinthe, Desboutin is in front of some innocuous beverage—there's a switch for you!—and we look like a couple of nitwits." *In a Café (The Absinthe Drinker)* (1875–6) was one of the artist's few paintings to become famous in his lifetime. It was bought by an English collector and raised eyebrows all over again when it went back on the market in 1892. Its unconventional layout and casual technique may have lost much of their shock value, but its subject clearly had not. In fact, Degas' friend George Moore thought it advisable at the time to set something straight: "The picture represents M. Deboutin [*sic*] in the café of the *Nouvelle-Athènes*. He has come down from his studio for breakfast, and he will return to his drypoints when he has finished his pipe. I have known M. Deboutin a great number of years, and a more sober man does not exist."

bows. There were large-scale dance compositions, such as the two *Dance Class* scenes in which dancer and choreographer Jules Perrot directs the corps de ballet. Dance also surfaced in numerous smaller drawings (often on sheets of pink or green paper), monotypes, and painted fans, whose limber dancers combined with the sweeping expanses of empty space attest to Degas' superb handling of the delicate medium of silk.

Women from All Walks of Life

In the 1870s, too, laundresses, café-concert singers, and prostitutes started to appear in his oeuvre. Edmond de Goncourt visited Degas' studio in February 1874, and

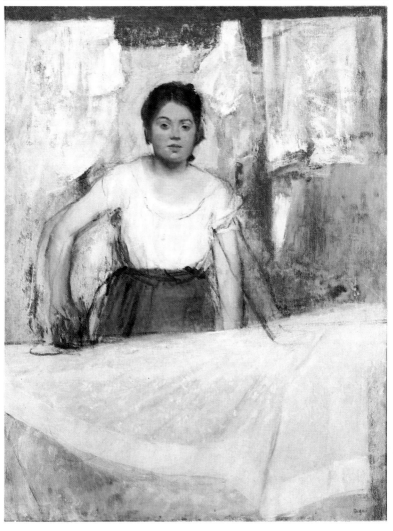

he noticed several pictures of laundresses and ironers he felt had been inspired by *Manette Salomon* (1867), a novel he and his brother had written. A little later, however, Zola was to acknowledge his debt to Degas:

This *Woman Ironing* is actually Emma Dobigny, a model who also posed for Corot and Puvis de Chavannes.

Hung at the fourth
Impressionist
exhibition (1879),
*Laundresses Carrying
Linen in Town,* like all the
work Degas exhibited,
drew a mixture of acerbic
criticism and enthusiastic
praise. The most
pertinent observations
were made by Armand
Silvestre in *L'Art
Moderne:* "Look at these
laundresses bent under
the weight of their
baskets. From a distance
it might be taken for a
Daumier, but close up it
is a good deal more than
a Daumier. There are no
words to describe its
calculated mastery; its
hold is indefinable.
It is a most eloquent
protest against the
muddled colors and
complicated effects that
are the undoing of
contemporary painting."

"In my book [*L'Assommoir*], I have, on more than one occasion, quite simply described some of your pictures."

The café-concert theme suddenly appeared around 1876–7, when Degas produced several monotypes featuring singers such as Emilie Bécat, famous for her jerky movements, miming risqué songs in the glow of Chinese lanterns at the Café des Ambassadeurs, or Thérésa, mouth open and hands drooping like paws, mimicking the four-legged hero of *The Song of the Dog*.

At the same time, prostitutes made their entrance in plush brothel parlors. They are shown patiently

The Song of the Dog (below left) was originally a monotype of a singer's head and torso, which Degas then enlarged by adding several strips of paper and reworked in gouache and pastel. The renowned Thérésa, shown here at an outdoor café-concert, had "the wittiest, most delicate, most naturally tender voice you ever heard."

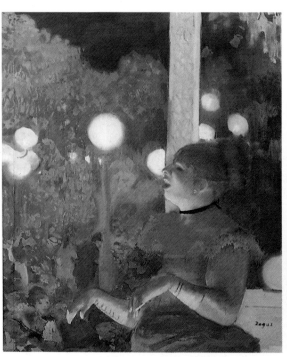

awaiting clients, enticing them with obscene gestures, or celebrating the name day of their beloved madam. They are almost always completely undressed except for the uniform of their occupation: neck ribbon, negligee,

stockings, garters, mules. One theory holds that the source for this astonishing series was Huysmans's novel *Marthe* published in 1876. Degas was once again in the mainstream of contemporary realism, but his daringly frank approach to these subjects anticipated all who were to follow in his footsteps. But he never dwelled on the vulgar aspects of a scene. "Whenever anyone deals with such subjects," Ambroise Vollard once noted, "it is often pornographic. It took Degas to give *The Name Day of the Madam* an air of celebration and at the same time the grandeur of an Egyptian relief carving."

T*he Name Day of the Madam* (1876–7, left) once belonged to Picasso, who bought it in 1958. "Degas' paintings have never interested me very much," he confessed. "But the monotypes are another story. They're the best things he did."

B elow: *Café-Concert Singer.*

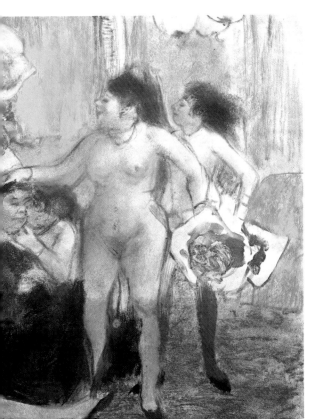

T hese monotypes inspired Picasso to produce a series of prints that cast Degas himself in the role of a voyeur among the prostitutes. "Degas would have given me a swift kick in the pants had he seen himself like that!" But after picturing Degas' every conceivable fantasy, Picasso concluded, "Printmaking itself is the true voyeur.... When you look at your copperplates, you are always the voyeur. That is why I etched all those embraces."

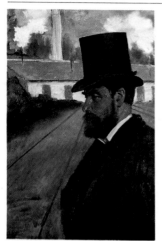

The novelty of these subjects should not overshadow the continuing, albeit diminishing, importance of portraiture. As was his custom, Degas asked only members of his immediate circle to sit for him: close relatives, such as his aunt, the dour Duchessa di Montejasi or his uncle Henri De Gas, caught sharing a quiet moment with Lucie, his niece; friends like Henri Rouart, shown in profile in front of his factory; the smartly dressed Mme. Jeantaud, stealing a final glance in the mirror before going out; the writer Edmond Duranty at his worktable, deep in thought against the multicolored backdrop of the books in his library; the Florentine critic Diego Martelli, uncomfortably perched on a cross-legged seat.

One after another, his portraits continued along paths he had pursued in the 1860s. Like *The Orchestra of the Opéra, Portraits at the Stock Exchange* is a portrait of an individual in a group set in his actual place of business; *Mme. Jeantaud Before a Mirror* is, to paraphrase Whistler, a harmony in brown; *The Duchessa di Montejasi with Her Daughters Elena and Camille* is a study in which the duchess' starched frontal pose provides a counterpoint to the

For this portrait of Henri Rouart (c. 1875, left), Degas updated a Renaissance formula—the half-length portrait in profile—by positioning his model slightly off center and adding a factory and puffs of smoke in the background to indicate his occupation. The rails converging on the noble head of this captain of industry look like rays of light emanating from a Christ Pantocrator.

In 1879 Degas painted two portraits of Florentine writer and critic Diego Martelli (1839–96), using for one of them a nearly square format (below) seldom seen in his oeuvre.

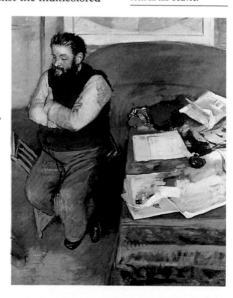

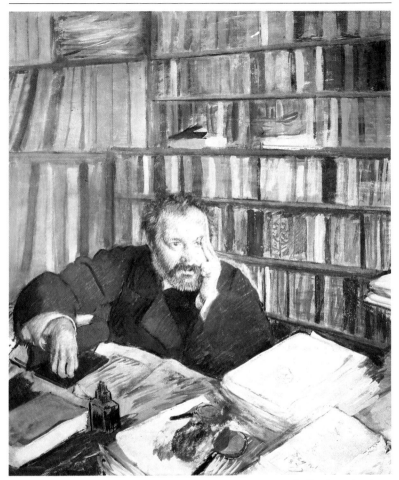

vivaciousness of her two daughters, shown in profile and relegated to the edge of the canvas. With its steep, angled point of view, *Diego Martelli* is in keeping with concerns he wrote about at the time. "For a portrait," we read in a notebook, "have your model pose on the first floor and work upstairs, to accustom yourself to retaining forms and expressions and so that you never draw or paint *immediately*."

Novelist and critic Edmond Duranty, whose landmark essay "La Nouvelle Peinture" (1876), the Impressionists' aesthetic charter, was strongly influenced by Degas.

" Is it the countryside, is it the weight of my fifty years that makes me feel so burdened, so sick at heart? People think me cheerful because I smile idiotically, resignedly. I am reading *Don Quixote.* Oh, fortunate man and what a glorious death!… Oh, where are the days when I thought I was strong, when I was full of logic, full of plans! I am quickly sliding downhill, rolling I know not where, wrapped up in lots of bad pastels, as if in so much packing paper. "

CHAPTER IV
"I AM QUICKLY SLIDING DOWNHILL"

Degas (c. 1885, opposite) could turn next to nothing into a masterpiece. With a few strokes of pastel, a dancer's satin bow becomes a huge moth perched on a piece of blue-gray paper.

Degas was fifty years old when he shared these morose thoughts with sculptor Albert Bartholomé. He continued in this vein a little later, in 1886: "There is something artificial even about this heart of mine. The dancers have sewn it into a pink satin bag, a slightly faded satin, like their ballet slippers."

In his correspondence Degas periodically lapsed into disillusionment that surfaced in comments about growing old, his impending death, loneliness, illness, money problems, and the gradual loss of close friends.

1880–90: Fame and Fortune at Last

Degas' life went through many changes in the course of this decade. In 1880 the painter was still overwhelmed by family debts. But when he moved in 1890, it was into a sprawling three-story apartment, which he now needed to accommodate his burgeoning collection of masters both old and new: Ingres, Delacroix, Corot, Courbet, Gauguin, Cézanne.

In 1880 Degas was eager to sell as much as possible; ten years later, he sparingly parceled out works to a select group of dealers (Boussod et Valadon, Bernheim Jeune, Hector Brame, Ambroise Vollard, and, still, Durand-Ruel). By this point, the artist had been acclaimed by such critics as Félix Fénéon and Georges-Albert Aurier. To quote Gary Tinterow (Boggs, et al., *Degas*, 1988) "Degas had relinquished his position as a conspicuous presence in the Paris art world in order to slip into comfortable obscurity, had passed from serious indebtedness to affluence, and had converted from Naturalism to Symbolism...."

The Degas who so often seemed embittered was also the Degas of fame and fortune. He had money, even if, as his sister Thérèse pointed out, "he never knows how

Degas' marked inclination toward unsteady poses crops up throughout his oeuvre, as if, on a deeper level, he was seeking an unattainable state of equilibrium. *Mlle. La La at the Cirque Fernando* (1879, opposite; study above) is clearly an allegory of this never-ending quest: Borne heavenward by a rope held in her clenched teeth, the acrobat, arms extended and legs bent back, has become part of a precarious and theatrical Assumption.

much he has." His work was selling steadily and readily. A good many artists looked up to him as a master. "His name, more than his oeuvre, is synonymous with character," Odilon Redon noted in March 1889. "It will come up whenever the principle of independence is discussed…. Degas deserves to have his name inscribed high on the temple. Respect here, absolute respect."

A Stay-at-Home Who Got Around

The tranquility of daily life was barely disturbed by two changes of residence—in 1882 to Rue Pigalle, in 1890 to Rue Victor-Massé—the death of Degas' housekeeper, Sabine Neyt, and the hiring of her replacement, faithful Zoé Closier, who stayed on until his death. As a rule, Degas left Paris in the summer to stay with the Valpinçons at Ménil-Hubert or with the Halévys on the coast of Normandy; late in the decade he took the cure at Cauterets, a spa in southwestern France. In 1889 he even traveled as far afield as Spain and Morocco. During each of these interludes away from home, he calmly divided his time between work and social gatherings. At Cauterets he was amused by the hodgepodge of aging blue-bloods, middle-class upstarts, and society women, like the Comtesse de Mailly-Nesle, future wife of the famous tenor Jean de Reszké. Unlike most contemporary artists, he

In the 1880s the painter, who had not used himself as a model since 1865, returned to self-portraiture, only this time in photographs, patiently holding poses for the camera by lamplight—with his housekeeper Zoé in the background (below and opposite below).

never brought back from these holidays some souvenir or other for his portfolios. He voiced his disappointment when nature failed to cooperate—"I promised you some drawings of mountains," he wrote Bartholomé in 1890 from Cauterets, "but I spoke too soon. There aren't any really appealing forms here. We're stuck, and thus far everything has left me cold"—and invariably longed for the peace and quiet of his Paris studio.

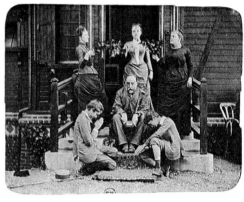

His precipitate, whirlwind tour of Spain in 1889 is a telling case in point. It began with an obsession— "I am still thinking about a trip to Madrid and a real bullfight" (to Bartholomé, Cauterets, 19 August 1889)—sustained by suitable reading material (tour guides, travel literature, bullfighting manuals) in order to "stuff [my] head with things Spanish." He left Cauterets in early September. During a stopover in Biarritz, he ran into Léon Bonnat on the upper deck of a streetcar; his old friend from Rome had been promoted to official portrait painter of state dignitaries.

Degas was spending the latter part of the summer of 1885 at Dieppe with the Halévys. Parodying Ingres' *The Apotheosis of Homer* (opposite above), Degas (above, center) mimics the blind poet's detached, world-weary pose while the daughters of journalist John Lemoinne pretend to be a trio of garland-bearing muses and Elie and Daniel Halévy worship at his feet.

He arrived in Madrid and visited the Prado, thrilled at seeing the works by Velázquez ("nothing, no nothing can give you an idea of Velázquez"), and attended a bullfight. A stint in Andalusia, then the urge to set foot on Moroccan soil "just for a few hours." Off to Tangiers, where Degas was amused by the guided tours—"Can you picture

me on a mule, taking part in a cavalcade led by a guide in a violet silk robe on the sand of a beach, along dusty paths in the countryside, and then across Tangiers?" (to Bartholomé, Tangiers, 18 September 1889)—and moved by the memory of Delacroix ("In nature one cherishes those people who have not been unworthy of her touch. I am telling you this because Delacroix passed this way").

Degas' brief tour of Spain and Morocco, from which he did not bring back a single work of art, was primarily a pilgrimage: He did it for Velázquez, for Delacroix, and, although he never mentioned him by name, probably for Manet, who had died a few years earlier. Surely what he had seen of Velázquez and bullfights must have reminded him of his friend.

The 1880s brought one distressing loss after another: Manet in 1883; the Italian painter Giuseppe De Nittis ("that singular, intelligent friend") the following year; and Alfred Niaudet, a schoolmate from now-distant Louis-le-Grand days and a cousin of his beloved Louise Halévy. "We buried Alfred Niaudet on Saturday," he reported to Henri Rouart. "Do you remember the guitar soirée at the house almost a year and a half ago? I was adding up the friends present: There were twenty-seven of us. Now four of them are gone.

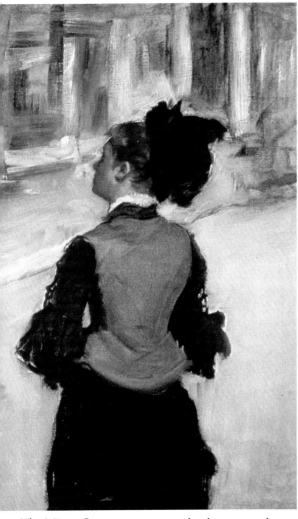

The Visit to the Museum (c. 1885) is a variation on the earlier Two Studies of Mary Cassatt at the Louvre: A young woman (who is not Mary Cassatt) in the Louvre is looking at paintings in blurred, but conspicuous gilt frames. English painter Walter Sickert, who befriended Degas in the summer of 1885, was reportedly told by the artist that "he wanted to convey the boredom, the crushing and deferential awe, the total absence of sensation women experience in front of paintings."

In the late 1870s, Degas planned to do some "portraits in a frieze to decorate an apartment." In all probability, Two Studies of Mary Cassatt at the Louvre (c. 1879, opposite) were somehow tied in with this projected "decorative scheme."

The Misses Cassatt were supposed to have come, but one of them is dead." (Mary Cassatt's sister Lydia died in November 1882.)

The void left by the deceased was filled by new acquaintances who, in time, became staunch friends

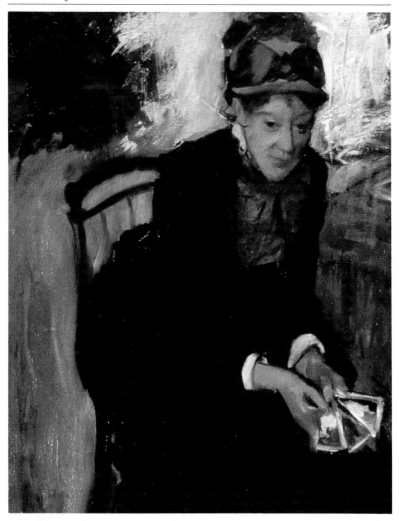

themselves. One was Henri Lerolle, who bought his first Degas in January 1883; another, Mary Cassatt (1845–1926), the American painter who in 1879–80 had collaborated with him on the proposed, but never published, periodical *Le Jour et la Nuit*. Cassatt

Mary Cassatt (c. 1884).

professed boundless admiration for Degas, and it was on her recommendations that the fabulously rich American Louisine Havemeyer built up her splendid Degas collection. In 1882 Cassatt posed for a number of the millinery scenes, but did so, she once admitted to Mrs. Havemeyer, "only if necessary, when he finds the movement difficult, and the [professional] model seems unable to grasp what he has in mind." For his part, Degas strongly encouraged Cassatt in her work, gave her advice, and bought several of her paintings, one of which, the famous *Girl Arranging Her Hair*, he displayed prominently in his apartment. However, as usual with Degas, their relationship was not always a smooth one. His fine portrait of her (c. 1884) shows the young American woman seated and holding some cards. Late in life, she criticized it sharply: "I do not wish to leave it with my family as being [a picture] of me," she wrote to Durand-Ruel in 1912–3. "It has its good points as art, but it is so distressing and depicts me as such a repugnant person, that I would not want it known that I sat for it." It was not only the graceless, unladylike pose that must have offended Mary Cassatt, but the role Degas assigned her in the picture: Holding out three playing cards to the viewer, she looks for all the world like an ironic, inscrutable fortune-teller (see the writings of Richard Thomson on this subject).

Mary Cassatt was not the only female friend in Degas' life at the time. There was also Rose Caron, a soprano acclaimed for her renditions of Gluck and Wagner, but even more famous for the roles she created in Ernest Reyer's two most noteworthy operas, *Salammbô* and *Sigurd*. Degas dedicated a sonnet to Rose Caron—one of several he wrote during the winter of 1888–9—in which he paid homage to the singer's powerful, beautiful voice and commanding stage presence: "These long, noble arms, slowly in passion,/ Slowly in affection so human and cruel,/ These arrows flung from a goddess' soul/ And which stray into an imperfect world," concluding with: "If my eyes should fail, may my ears serve me still:/ Her voice shall make

Mary Cassatt at the Louvre: The Paintings Gallery is perhaps Degas' most famous etching. There are some twenty states in all (below, the 15th–16th intermediate state in the Bibliothèque Nationale, Paris), and Degas made substantial changes in tone and texture from one state to the next. Looking more like a dilettante than a committed art lover, more a fashion plate than a painter, Mary Cassatt is shown leaning on an umbrella while observing some pictures from a distance. Her companion, holding a collection catalogue, is probably her sister Lydia.

plain what they cannot see."

He painted a portrait of her a few years later (c. 1892). Most of the soprano's face is in shadow, but we can clearly make out its "Aztec" features and the emphatic movement of the woman's arms as she pulls on a glove. "Divine Mme. Caron," he wrote, "speaking to her in person, I compared her with the figures of Puvis de Chavannes, which were unknown to her."

An Enduring Love for Opera

Opera remained one of the painter's ruling passions. Documents in the National Archives in Paris chronicle the performances Degas attended between 1885 and 1892, as well as the nights he went backstage. During this period Degas saw Reyer's *Sigurd* no fewer than thirty-seven times—chiefly, it is assumed, to hear Rose Caron in the role of Brünehilde—Verdi's *Rigoletto* fifteen times, Delibes' ballet *Coppelia* thirteen times, Rossini's *William Tell* and Donizetti's *La Favorita* twelve times each, Gounod's *Faust* eleven times, and Meyerbeer's *L'Africaine* and Verdi's *Aïda* ten times each. He also saw masterpieces of French grand opera: Halévy's *La Juive*, Meyerbeer's *Les Huguenots, Robert le Diable*, and *Le Prophète*, as well as more recent works (Massenet's *Le Cid*, Gounod's *Roméo et Juliette*) and operas that have since vanished completely from the repertory (Paladilhe's *Patrie* and Saint-Saëns' *Ascanio*).

This list clearly attests to Degas' musical tastes, his predilection for a genre that seemed outmoded even then—French grand opera—and his oft-avowed aversion to Wagner. (In 1891 and 1892 he saw *Lohengrin* only twice, even though Rose Caron sang the role of Elsa.) It also ties in with the important place opera and ballet continued to hold in his oeuvre. At

A sampling of the many sketches Degas started drawing at the Opéra in the 1860s: an orchestra musician's seat, a comically shaped double bass, the massive back of a subscriber in the front row of the orchestra. Degas was not given permission to go backstage on a regular basis until 1885.

this time Degas was turning out one rehearsal scene after another—some forty in all, a veritable series—in unconventional horizontal formats. Their reduced scale and oblong shape encouraged inventive handling of compositional elements: long bare walls, occupied and empty space, usually glaucous light, sometimes a double bass lying on the floor to add a lighthearted touch. The dancers are yawning, stretching, and resting exhausted bodies that often demonstrate signs of obvious fatigue, even pain.

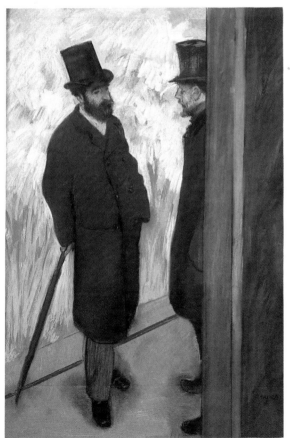

Exhibited in 1879 at the fourth Impressionist exhibition, *Portrait of Friends in the Wings* shows two members of Degas' immediate circle, Ludovic Halévy (1834–1908, left) and Albert Boulanger-Cavé (1832–1910), chatting in the wings. "Yesterday Degas exhibited a double portrait of Cavé and myself," Halévy reported in his *Journal*. "The two of us are standing face to face in the wings. Me looking serious in a place that's light and gay: The very thing Degas wanted to achieve." A brilliant writer, Ludovic Halévy, together with co-librettist Henri Meilhac, was instrumental in introducing Degas to the closed world of the Opéra. The perpetually idle Albert Boulanger-Cavé and Degas, who liked him despite his listlessness, made for a curious twosome once described as "Degas, hard work incarnate, and Cavé, its foe." "Cavé did stand out in one respect," noted Daniel Halévy: "He did nothing with his life. Absolutely nothing."

As a rule, these pictures were sold to Durand-Ruel. Now and again he would threaten to sell to other dealers, or badger him with incessant, and sometimes less than cordially worded, requests for money: "You have put off coming to see the pastel, so I am sending it to you," he wrote to Durand-Ruel on 13 August 1886. "You'll be getting another (of horses) and a little racetrack scene (in oils) with a background of mountains. Kindly send me some money *this afternoon*. Do try and come up with half the sum each time I send you something. Once I'm back on my feet, I may see fit not to set anything aside for you, and I'll be able to pay off all my debts in full. At the moment, though, I am dreadfully hard up. That's why I was a little anxious to sell this pastel to someone other than you—so I could get paid in full." Degas needed fresh infusions of cash to indulge his latest passion, collecting, which was to peak in the 1890s, when he made his most important purchases.

Durand-Ruel's monopoly on the Degas market came to an end in 1887, when the artist consigned one of his important early paintings—*Woman Leaning near a Vase of Flowers*, wrongly called *Woman with Chrysanthemums* (1865)—to Vincent van Gogh's brother, Theo, who represented Galerie Boussod et Valadon. Their association ended with Theo's death in 1891. As the decade drew to a close, Degas sold less and less regularly and became as particular about what he put on the market—both his latest work and early paintings, too—as he was about his dealers. This increasingly independent attitude toward the art market went hand in hand with his growing popularity. He also became extremely selective about where he exhibited his work.

Contention Among Colleagues: Degas, Gauguin, Pissarro

Impressionist exhibitions were still considered major events, but the

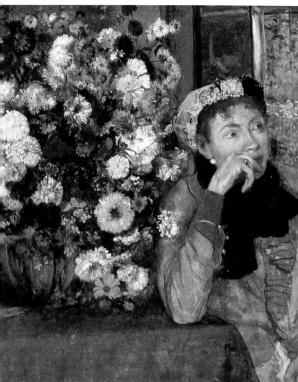

Degas did not limit what he put on the market to his most recent work. For example, the artist sold *Woman Leaning near a Vase of Flowers,* from 1865, to dealer Theo van Gogh, the painter's brother, in 1887.

Unlike Monet, Pissarro, Renoir, and Sisley, Degas balked at the prospect of one-man shows; nor did he take part in the Paris Exposition of 1889. A highly selective exhibitor, he acquiesced in the public showing of several pictures in April 1883 (London), April–May 1886 (New York), and 1888, the year Durand-Ruel opened a New York branch of his Paris gallery. However, he did have a hand in all the Impressionist exhibitions (an announcement for the 1886 show is opposite), every one of which was marred by feuding or tension among the participants.

dominant role Degas played in organizing them now came under heavy fire. Paul Gauguin did not trust him and was afraid he might "throw a monkey wrench into the works." His chief objection—one echoed, though less vehemently, by Gustave Caillebotte and Camille Pissarro—stemmed from Degas' insistence that some of his friends be included in group exhibitions. In 1882 an offended Degas paid his dues but sent nothing to the show. In 1886, at the last Impressionist exhibition, he hung only ten of the fifteen works of his listed in the catalogue, but those ten won critical acclaim. A "series of female nudes bathing, washing, drying themselves, wiping themselves off, combing their hair or having

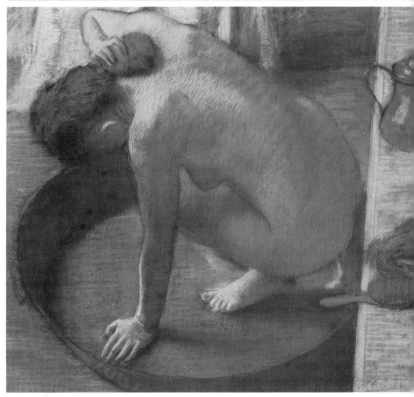

their hair combed" created more of a stir than Seurat's *Sunday Afternoon on the Island of La Grande Jatte,* now considered the showpiece of the 1886 exhibition.

And so ended the tumultuous era of the Impressionist exhibitions, each a milestone in the history of art. Although never an Impressionist as such, Degas faithfully stood by this avant-garde movement to the very end. The obstinacy with which he pushed some of his friends—Federico Zandomeneghi, Mary Cassatt, Giuseppe De Nittis, Jean-François Raffaëlli—was simply the tribute he exacted from his colleagues for the privilege of profiting by his presence.

Relations between him and his onetime associates

Woman Bathing in a Shallow Tub (1886, above) is one of the seven pastel drawings that Degas made of this subject in the mid-1880s.

became strained. "Despite everything"—the rebuffs, Degas' difficult disposition, his virulent anti-Semitism in later years—Pissarro's tremendous admiration for him remained intact. Degas was increasingly reticent about Monet and considered him more a clever businessman than a genuine artist. "Degas was one of the harshest [critics]," Pissarro recalled, referring to the paintings Monet exhibited in 1888. "He regards it all as nothing but art designed to sell. Besides, he has always been of the opinion that Monet, for some inexplicable reason, turned out nothing but beautiful decorations." His real friends were uninspired, second-rate painters, capable enough but totally lacking in the genius of the Impressionist masters.

Women, Horses, and More Women…

In these later years Degas seldom exhibited and sold intermittently, but he was working as steadily as ever, tirelessly probing the limited range of subjects he had started to explore in the 1870s.

Women—dancers, milliners, ironers, bathers—overshadowed this period; portraits and racetrack scenes surfaced only on occasion. The latter, however, benefited from the research of Eadweard Muybridge and Etienne Jules Marey, who discovered that movement could be "frozen" in a quick succession of photographs. The periodical *La Nature* (14 December 1878) had already published plates of a horse moving at different speeds. In 1887, Degas pored over Muybridge's *Animal Locomotion*, copied two frames in it, and based several pieces of sculpture on the published photographs.

Earlier in the decade Degas had made extensive changes to two key racecourse scenes from the 1860s:

" Here, a plump and well-padded redhead is bent over, her sacrum protruding above the taut curves of her buttocks; she is straining to reach back behind her shoulder in order to squeeze a sponge and send a trickle down her spine and lapping over the small of her back. "
Joris-Karl Huysmans

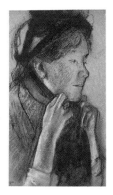

Above: Mary Cassatt was Degas' model in this study (c. 1882) for the pastel *At the Milliner's.*

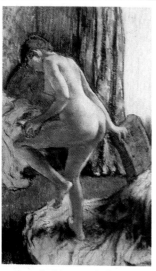

The Steeplechase (final variant c. 1896–8) and *The Gentlemen's Race: Before the Start*, a canvas originally painted twenty years earlier. In the latter, he completely remodeled what had been a country setting by adding curious factory smokestacks, reworking the faces of the jockeys, and fleshing out the bodies of once-wiry horsemen and mounts. The fact that these approachable scenes found a ready audience during the 1880s encouraged the painter to do more of them.

For the most part, however, he focused his attention on women. We see them trying on hats in a milliner's shop, where bonnets on display stands cut a dazzling diagonal swath across the canvas or sheet of paper. Or at the ironing board, toiling wearily or, bottle in hand, stretching and yawning. Or in tutus, now onstage taking a bow, now backstage rehearsing a step one last time or fastening a shoulder strap. Or alone in the privacy of their rooms, washing and drying themselves, briskly rubbing themselves down, dressing their hair or having it dressed, often anonymous, their faces unseen and inscrutable, unblushingly displaying their breasts, buttocks, hips, and broad, powerful backs because they think they are doing so unobserved.

At the time, all of these nudes were

Degas chose an unusual upright format for *After the Bath* (probably c. 1883–4, left), the first of his large-scale treatments of this theme.

He very often drew preliminary nude studies for his dance compositions, as he had once done for his history paintings. The plaintive *Nude Dancer with Her Head in Her Hands* (c. 1882–5, below) is a monumental figure that almost completely fills the narrow sheet of paper.

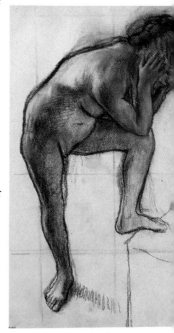

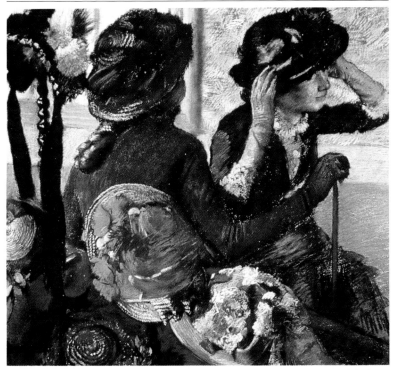

considered cruel because they were so true-to-life.
Some maintained, and still maintain, that the artist
was a voyeur who looked upon women as animals
and reveled in their mechanical, uninhibited poses.
Others—van Gogh was the first—saw these quasi-
clinical representations of the female body as an
outgrowth of the painter's sexuality. "Degas' painting
is virile and impersonal," Vincent wrote to painter
Emile Bernard, "precisely because he personally has
acquiesced to being nothing but a little notary who
shudders at the thought of debauchery. He watches
human animals that are stronger than he is, animals
that [have sex] and [have more sex], and he paints
them well precisely because he himself has no such
pretentions about [having sex]."

At the Milliner's
(1882) is perhaps
the most beautiful of the
pastels in the series that
portrays young women
as mannequins. Here
Degas laid particular
stress on an incongruous
combination of
juxtaposed or overlapping
hats—singular still
lifes contrived out of
curious assemblages of
leaves, feathers, and
pieces of fabric.

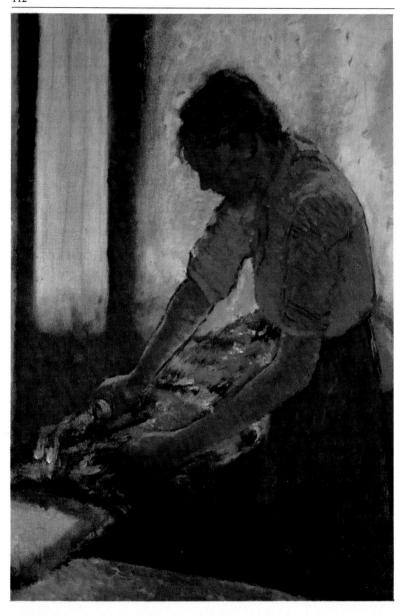

" It was increasingly difficult for him to hear, and his eyes were of almost no use to him." That is how Ambroise Vollard described Degas in 1912. Absorbed in solitude, cut off from emerging avant-garde movements, gradually going blind, Degas, increasingly removed from the world, lingered on.

CHAPTER V
"I'M LETTING EVERYTHING GO"

Degas' late views of women include *Woman Ironing* (c. 1892–5, opposite) and *Bather Seated on the Ground, Combing Her Hair* (c. 1896).

He was still in full command of his faculties in the 1890s, however, and was said to be "fencing" with a pastel as late as 1907. In 1910 model Alice Michel reported that he was having difficulty working; Ambroise Vollard tells us that he stopped working altogether in 1912, after changing residences. Degas' building on Rue Victor-Massé was slated for demolition, forcing him to vacate, store his largest paintings at Durand-Ruel, and move to 6 Boulevard de Clichy: This involuntary relocation unquestionably marked the beginning of the end. Unable to acclimate himself to the new premises, Degas let his work fall by the wayside. On 10 December 1912 Daniel Halévy listened as Degas sadly took stock of himself: "You see, my legs are good, I get around all right. But since I moved, I no longer work…. I don't care, I'm letting everything go. It's astonishing, how indifferent you become in old age."

The Long Start of a Slow Death

In the 1890s, little by little, the artist turned in on himself, deliberately opting for seclusion. Even in the early years of the decade he ventured out less frequently, stopped seeing all but a handful of friends, and after 1892 was no longer a fixture at ballet rehearsals. Durand-Ruel organized an extremely rare one-man show of Degas landscapes in 1892, but on balance the artist authorized fewer and fewer exhibitions. Venting his bitterness about growing old, he gradually cut himself off from everything.

Otherwise, at this point, there was no change in the routine of everyday life: unremitting work in the studio until evening, then a plain meal prepared by faithful Zoé Closier, unless friends like the Halévys (until 1897) or the Rouarts had him over for dinner. As was his custom, he spent summers with the Valpinçons at Ménil-Hubert or the Rouarts at La Queue-en-Brie, later with the Braquavals at Saint-Valéry-sur-Somme, a place he had known since childhood. On rare occasions he traveled more extensively: Switzerland, a tour of

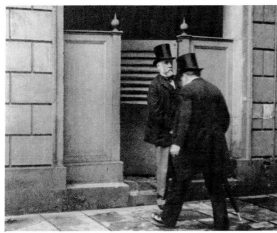

In July 1889 Count Giuseppe Primoli photographed Degas emerging from a public urinal. "Had it not been for the person going in," the artist wrote, "I'd have been caught in the ridiculous act of buttoning my trousers, and everyone would be laughing!"

Opposite above: *Dancer Looking at the Sole of Her Right Foot,* c. 1895–1910.

It is impossible to identify the exact location of Degas' landscapes. His one-man show of monotypes at Durand-Ruel in 1892 prompted the *Mercure de France* to make a remark about "chimerical places reconstructed from the imagination" and to compare Degas' works to those by Symbolist artists. Today they tend to be seen as a major step toward abstraction. Although certain forms can be made out in some of the paintings after considerable effort, others are merely assemblages of shapes, powerful but indecipherable, evocative but abstruse. Left: *Landscape,* 1890–2.

Burgundy by horse and gig in the fall of 1890, and a trip to Naples in 1906.

Degas' financial worries were behind him. He was selling more erratically than ever, but at higher prices,

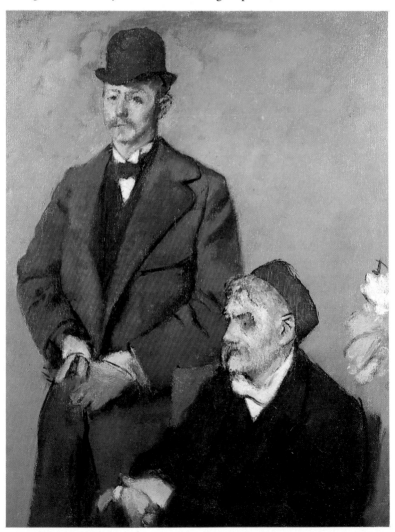

often to purchase a painting for his own collection. He no longer had to concern himself with group exhibitions and lavished encouragement and advice on other artists: sculptors Paul Paulin and Albert Bartholomé, painters Jean-Louis Forain, Louis Braquaval, and Suzanne Valadon, whom he insisted on calling "terrible Maria."

Several of his contemporaries died in quick succession, and the inexorable loss of cherished associates left Degas more isolated than ever. Berthe Morisot passed away in 1895, Mallarmé in 1898, Toulouse-Lautrec in 1901, Gauguin and Pissarro in 1903, and Cézanne in 1906. His circle of relatives and close personal friends also shrank. Death claimed his first cousin and brother-in-law, Edmondo Morbilli, in 1893; Paul Valpinçon in 1894; his sister Marguerite in Buenos Aires in 1895; his friend Evariste de Valernes in 1896; and Henri Rouart—one of the Rouarts Degas referred to as his family—in 1912.

He did enjoy the company of young people, though. Julie Manet, the daughter of Berthe Morisot and Eugène Manet, saw quite a bit of Degas in the 1890s. In *Degas Dance Drawing,* Paul Valéry reports that he met Degas at Henri Rouart's in 1893 or 1894—he saw him as "a character reduced to the disciplined linework of a stern drawing: a Spartan, a Stoic, a Jansenist of art"—and called on him regularly until the painter's death. Ludovic Halévy's son, Daniel, had many discussions with Degas and faithfully recorded them in his *Notebooks.* But the Dreyfus affair was to change all that.

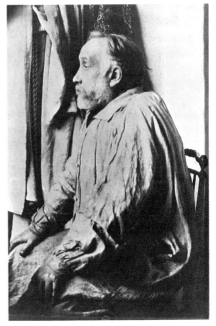

Degas had always been haunted by the idea of old age and the deterioration it entails. This startling painting from the late 1890s shows his old friend Henri Rouart—his eyes mere sockets, his hands folded over a cane—huddled in an invalid's armchair beside his vain, smartly dressed son Alexis. It is the culmination of a theme Degas first explored in 1857 with the portrait of his grandfather Hilaire.

Above: Degas in his studio, c. 1898.

"*It* Came Up"

In 1894 a French army officer, Alfred Dreyfus, a Jew and an innocent man, was convicted of treason and sent to Devil's Island to be imprisoned for the rest of his life. The case became a major political issue for more than a decade, dividing France into two camps, anti-Semites and royalists on the one hand and the anticlerical Dreyfusards on the other.

From the start of the Dreyfus affair, Degas was a committed anti-Dreyfusard and did not refrain from making anti-Semitic remarks. However, he did not sever his ties to the liberal (and partly Jewish) Halévys; in fact, he continued to call on them regularly, confident that both sides would say nothing about the issue to spare the feelings of all concerned.

And they did—that is, until the evening of 23 December 1897, when "*it* came up." Here is Daniel Halévy's incomplete account of the incident: "Degas broke bread with us for the last time. I do not recall who the other guests were. Probably some young people who were careless about what they said. Conscious of the threat that hung over us, I watched his face closely: His lips were sealed, his eyes raised upward almost constantly, as if to detach himself from the company around him. Had he spoken he would no doubt have come to the defense of the army, the army in whose traditions and virtues he set such store, now being insulted by our intellectual speculation. Not a word passed through those sealed lips, and when dinner was over Degas disappeared. The following morning, my mother read without comment a letter addressed to her, then silently handed it to my brother Elie, hesitating to grasp its contents."

This letter, which provides the key to Degas' attitude, was recently rediscovered: "My dear Louise, you will have to allow me to beg off this evening, and I might as well tell you right away that I am asking you to do so for some time to come. Surely you did not suppose that I'd have the fortitude to be cheerful and entertaining all the time. We're done with laughter. In your

" I said that a man could not be judged by a mere opinion. But a hue and cry was raised against me, and…I would have been overpowered if Renan's son, Ary, had not been there to back me up. 'I have watched Degas live for twenty years,' he said, 'and I have never known him to be at fault.' "

Daniel Halévy

kindness you thought I might fit in with those young people. But I am an imposition on them, and they are an even more unbearable one on me. Leave me in my corner; I'll be happy there. There are some very good times to remember. If I subject our bonds of affection, which go back to your childhood, to further strain, they will break. Your old friend, Degas." Thus, the controversial remarks of some young people ended a longstanding friendship that had withstood the Dreyfus affair for three years.

Below: Double exposure with Daniel and Ludovic Halévy and others, 1895.

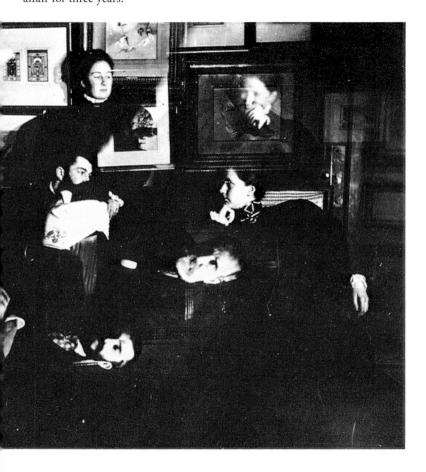

The Dreyfus affair had serious consequences for Degas, since it spread his reputation as a reactionary, anti-Semitic artist. The sad fact that he certainly *was* an anti-Semite remains the most disconcerting aspect of this otherwise great and thoughtful man.

Degas the Collector and Photographer

During the 1890s Degas channeled most of his enthusiasm into the noble cause of expanding his personal art collection. His tenacity alarmed his friend Bartholomé, who in 1896 described it as an obsession that was liable to bankrupt him: "Now [Degas is collecting] paintings with an intensity that I am afraid troubles Durand-Ruel, and which troubles me for his future." At the time, Degas was purchasing the showpieces that would turn him into one of the foremost collectors of the day. In late 1893 and soon thereafter he bought—at reasonable cost—two of Gauguin's masterpieces, *The Moon and the Earth* and *The Day of the God;* at the sale of the Millet collection (25 April 1894), El Greco's *Saint Ildefonso;* the following year, Delacroix' *Baron Schwiter.* In December 1895 he exclaimed as he showed his collection to Daniel Halévy, "I buy and I buy! I can't stop myself any more!" What Bartholomé described as "the highlight of his collecting career" occurred in January 1896, when Degas bought Ingres' portraits of Jacques-Louis Leblanc and his wife, which he remembered having seen in their son's house back in 1855.

In a letter to Paul Lafond, the curator of the municipal museum at Pau, France, and one of Degas' earliest biographers, Bartholomé dismissed this mania for acquiring art as another passing fancy, like his collection of walking sticks and photography. For, in later years, Degas was as intrigued as ever by the latest technical

" Whether consciously or not, Degas pursued effects resembling older, more primitive manifestations of camera work: a subject's stillness, the controllable art of posing, and most interesting of all, perhaps, the strange unearthly illumination of daguerreotype and calotype. "
 Eugenia Parry Janis

innovations and in 1895 threw himself into photography.

He bought a camera, probably an Eastman Kodak No. 1, and, as Daniel Halévy points out, used it "with the same energy he put into everything he did." He insisted on using the photographer's traditional paraphernalia of tripod and glass plates, as he was not primarily interested in taking snapshots. Degas did his picture-taking at night, in part because his daylight hours were taken up with studio work, in part because his principal aim was to use photographic images to explore "the atmosphere of lamps or moonlight." Some of his most beautiful portraits were made at the Halévys'. His carefully positioned models would have to keep still for long periods of time in an eerie, sometimes inscrutable

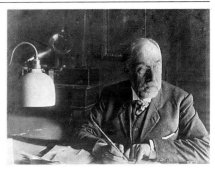

Photographs by Degas. Above: *René De Gas,* c. 1900; below, left to right: two versions of *Dancer from the Corps de Ballet,* c. 1896; *After the Bath,* c. 1896.

space that gives them a phantomlike presence. At
one time or another, Renoir, Mallarmé, Verhaeren,
the Halévys, Degas himself, and his brother René
posed in front of his lens, feigning nonchalance in
clever tableaux.

The Compulsive Craftsman, Forever Exploring New Paths of Expression

The striking thing about this career of nearly sixty
years is that, unlike Monet or Renoir, who enjoyed
comparable longevity, Degas never relied on set
formulas, meekly turning out dependably popular
material that would go down well with an established
clientele. He continually felt the need to discover fresh
techniques and unconventional means of expression.

Degas' late period in no way belied the dogged, even
astringent, determination of his youth and maturity.
His was a glorious old age not unlike that of Titian or,
in our own century, Picasso, whose life now seems to
parallel Degas' in many ways. From 1890 to 1900 he
kept breaking new ground with works long considered
unsettling but which, to quote one critic, produced "the
most surprising results. His shrill, off-key, dissonant
tones burst forth in gleaming fanfares…and show no
concern for veracity, verisimilitude, or believability."

Degas himself referred to his *Russian Dancers* as an
"orgy of color." In these pastels, as well as in the last
nudes and dancers, "overwhelming" (his own word),
unorthodox colors—canary yellows, radiant pinks,
muted greens, vibrant blues—underscore his incisive,
eloquent linework. His drawing was starting to
show an abandon and a forcefulness that informed
some of his sketches of the 1900s with expressionistic
power. Faces lost definition as their individualized
features faded into a blur of nameless contours and
movements. His compositions became increasingly
monumental and displayed a newfound willingness to
make the most of expansive formats. The subjects
remained the same, only simplified, abbreviated, with
an increasingly overt contempt for verisimilitude.

The astonishing *Fallen Jockey* (c. 1896–8) is a reworked version of *The Steeplechase* (1866), one of Degas' earliest compositions. He eliminated all but two figures: a horse hovering stiffly overhead like a medieval angel of death, and a jockey sprawled on the ground like a disjointed jumping jack. The setting is unidentifiable, the time of day uncertain, the anatomical inaccuracy of the horse's movement a throwback to a time when there were no photographs by Muybridge and Marey to consult. From now on, Degas flouted scientific discoveries and concentrated on a purely sculptural approach far removed from conventional representation of objective reality.

Degas turned his back on the realism he had leaned toward in the 1880s: Now his jockeys wandered about in vague, unintelligible country settings that have nothing to do with identifiable racecourses. Dressed in

ever-brighter silks, they are heading for parts unknown, for reasons unknown.

Perhaps that is also why in the 1890s Degas returned to landscapes, which had interested him only sporadically back in 1869. He found in them a way to distill the places he had glimpsed in passing, and filtered them through his memory into a unified vision. He began the landscape monotypes in October 1890, during a trip

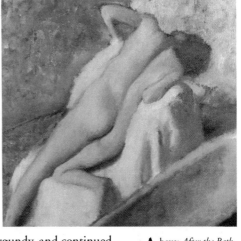

A bove: *After the Bath,* 1896. Below, left to right: *View of Saint-Valéry-sur-Somme,* 1896–8; *At Saint-Valéry-sur-Somme,* 1896–8; and *The Return of the Herd,* c. 1898.

by horse and gig through Burgundy, and continued working on them until 1892. They were, he told Ludovic Halévy, "vague things, perhaps," that reflected not "my state of mind" but "my state of eyes." He first experimented with colored monotypes at the country house of painter Georges Jeanniot, who described Degas' work method, how he would draw a landscape with brush or fingers on an oil-coated plate: "Gradually we saw emerging from the metal surface a valley, some sky, white houses, fruit trees with dark branches, birches and oaks, rivers swollen by a recent shower, a line of clouds scudding across a turbulent sky above the red and green earth…. These lovely things emerged with no apparent effort on his part, as if he had the actual scene before him."

Probably the most characteristic aspect of Degas' later years was his obvious determination to turn the routine events of everyday life—a woman bathing or having her hair done, a ballet dancer taking a breather on a bench—into works that lie squarely in

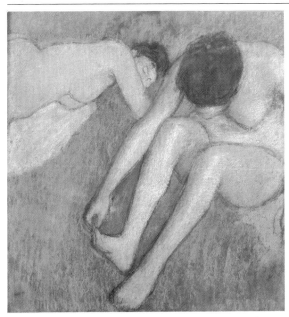

Degas did his last oil landscapes in 1898 while staying with painter Louis Braquaval at Saint-Valéry-sur-Somme, in northwestern France. He reverted to a literal representation of the scenes before him but emptied the town of its inhabitants, leaving only a baffling herd of cattle to roam among some low houses. The total absence of human figures conspires with the uncertain time of day and the muted harmonies of orange, lavender, or yellow to create disconcerting, enigmatic compositions that are as little-known today as they were then.

the tradition of the old masters and hark back to the great religious or history paintings.

His linework became more emphatic, more economical, at times anticipating Matisse. Sometimes he scaled his colors back to a two-toned play of reds and whites; at other times he let them explode in a bright, sumptuous palette that anticipated Bonnard: Witness *The Coiffure* and *After the Bath*. Stage scenery turned into real landscapes for incomprehensible dancers to move in; the last few portraits are simplified, unsettling likenesses that could easily be described as

expressionistic. Now pared to essentials, everything seemed to take on new tension and monumentality.

A protracted decline punctuated by the remarks of a few eyewitnesses—that is the story of Degas' life between July

1912 and 1917. "Degas is nothing more than a wreck," wrote Mary Cassatt in 1913. In 1915 his brother René filed a disheartening report with the artist's friend Paul Lafond: "Considering his age, his physical condition is certainly not all that bad; he eats well, suffers from no infirmity save deafness, which is getting worse and makes conversation very difficult…. When he goes out, he cannot walk much past Place Pigalle; he spends an hour in a café, and it is all he can do to get back…. His friends seldom come to see him because he hardly recognizes them…. Sad, sad end! He is dying slowly but without suffering, without anxiety, well looked after by people devoted to him."

Shortly before Degas' death, which came peacefully on 27 September 1917, Bartholomé saw him again

and described him as "more beautiful than ever, like an aged Homer, his eyes gazing into eternity." Degas was laid to rest in the family vault at Montmartre Cemetery. Then came the sales in 1918 and 1919 that marked the beginning of his immortality: The hundreds of works of art found in his studio were auctioned off. His close friends deplored this dispersal, but through it people finally and suddenly became aware of the breadth and diversity of his lifework.

If we must hold but one image of Degas in our minds, let it be the following: One day in the spring of 1911, Degas went to the Ingres exhibition then being held at Galerie Georges-Petit. Nearly blind, he said to Daniel Halévy, "I can find something in those pictures I know; those I do not know mean nothing to me." He kept standing there in front of the paintings, Halévy tells us, "touching them, running his hands over them"—an artist to the end.

In 1913 Bartholomé sadly reported on Degas' condition (left: Degas, c. 1908): "Good old Degas has changed a great deal—not that he is ill! He's never been in better health, lives outdoors from morning till night. Mentally, however, he is a mere shadow of his former self and that fine memory of his is fading, along with his drive and zest…. He still says, 'I am a tiger,' but he's lost his bite."

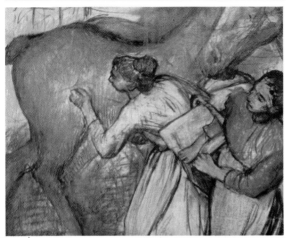

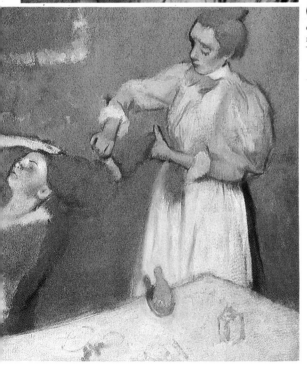

Washerwomen and Horses (c. 1904) is a curious combination of two of Degas' favorite subjects. The implausibility of putting basket-toting laundry girls in the same scene as massive draft horses was immaterial.

The Coiffure (c. 1896) belonged to Matisse, who must have admired the size, monumentality, and brilliance of this subtle "harmony" in red.

Overleaf: Dancers at the Barre (detail), c. 1900, and sketch of a mounted jockey, 1882.

DOCUMENTS

Degas' correspondence and the recollections
of his friends illuminate the life of a breakaway
artist with a consuming interest in
painting and sculpture.

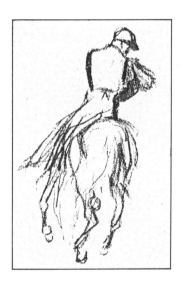

Degas Through His Letters

Degas had a gift for writing letters, which he demonstrated over the course of his sixty-year career. The letters range from lengthy disquisitions on his travels, changing moods, and ongoing projects to terse notes requesting money or accepting a dinner invitation.

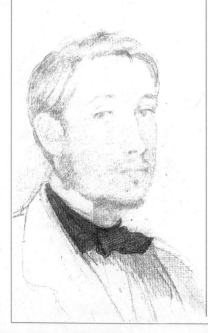

Degas' collected correspondence, edited by Maurice Guérin, was first published in 1931 (in French). Since then, many previously unpublished letters have come to light, including several Degas wrote to Gustave Moreau in 1858 and 1859.

TO GUSTAVE MOREAU
Florence, 21 7bre
[September 1858]

My dear Moreau,

I can see that in order to get news of you I must ask for it. I take it you are well and that you are engrossed in your family and with color. If I am dropping you a line it is not so much to tell you what has become of me as to more patiently await your return by receiving or expecting a letter from you. Not much has become of me. I am rather bored, as I am all alone. In the evening I am a little tired from the day's activities and could do with a bit of conversation. I have no cause to open my mouth. [Painter John] Pradier is here but is not a very encouraging example. [Watercolorist John] Bland is surrounded by Englishmen I do not know. So, after I've had an ice cream at the Café Doney I go home before nine o'clock; sometimes I write as I am doing now; usually I read before and after retiring, and you know the rest. My aunt has not come back yet. My grandfather's death in Naples has detained her a while. There are times when I am so peeved by my loneliness and so fretful about my painting that, if I were not held back by my longing— and you know how strong it is—to see my aunt and little cousins again, I should forego beautiful Florence and the pleasure of your return.

I told you I intended not to talk at all about myself, and here I have been

I've almost finished a copy of Veronese's angel from his sketch, and I've begun the Giorgione landscape (*The Judgment of Solomon*), in the same size; I might put the figures in. I have done a few drawings. All in all, I have been less courageous than I expected to be. I refuse to give up before I get results, though. As I am at loose ends here, I might as well make the most of my time and study my craft. I could not undertake anything on my own. I have started down a hard path that requires great patience. At one time I had your encouragement; now that I no longer do, I am starting to despair a little, the way I used to in the past. I remember the conversation we had in Florence about the sorrows that are the lot of those involved in art. What you said was less exaggerated than I thought. There is indeed little compensation for those sorrows. They increase the older you get and the farther along you go, and the consolation once derived from youth's few additional illusions and hopes is gone. However great one's affection for one's family and one's passion for art, there is a void even they cannot fill. I do hope you see what I mean, even though I'm not expressing it very well.

I am talking about sadness to you of all people, who must be blissfully happy. For the love of your family must fill your heart to overflowing. You are probably reading this the way I listened to you, with a smile.

Still about me. But what did you expect to hear from a man who is as lonely and forlorn as I am? A man who has only himself before him, sees no one but himself, thinks of nothing but himself. A great big egoist.

I sincerely hope you will not put off

Above: A study after Masaccio. Opposite: A self-portrait in pencil.

talking about nothing else. You would never know that I am reading with interest the *Provincial Letters*, which advises us to detest the self.

One more thing about me, then no more: I have finished my sketch of the Giorgione; it took nearly three weeks.

your return. It has been over a month since you left; you gave your word you would spend only two months in Venice and Milan. I hope I shall be able to wait for you.

Study of an Italian Woman.

M. [Edmond] Beaucousin [a collector] spent some three weeks here. His company distracted me a little. Imagination is not his strong suit, as you know. He noted down the whole of Florence so he wouldn't buy any bad pictures. That is all he aspires to. He asked to be remembered to you....

You will show me something by Carpaccio, or tell me about it, won't you? Here I shall lead you to a Botticelli in the Accademia I am sure you are not familiar with. It is an allegory. I'd rather not tell you anything about it and make your mouth water. M. Beaucousin told me Carpaccio was a most singular and original painter. There is a St. Stephen of his in the Louvre, surely you remember it.

Your hat and box are just fine. I shan't forget to do your shopping at Livorno. I'll probably go there to meet my aunt in about ten days.

Did you get my letter with the address you asked me for?

I can picture you in front of the Martyrdom of St. Peter with *lots of white* precisely because it is very dark, and a *big canvas* because you like small people or people small. It is hardly mediocre, as you can see.

What has become of Clère, Delaunay, Lionnet, Gandais, and the illustrious Gaillard? Carpeaux has left. Bland will come back, I think.

Any news from Lévy and de Courcy? You might at least write to me with news of yourself.

Good-bye. An affectionate handshake.

Yours ever,

E. De Gas

*S*tudy of Sailors.

TO GUSTAVE MOREAU

Paris, 26 April [1859]

My dear Moreau,

Here I am back in my native land. Although I have been here about three weeks, I still feel as if I am in a complete daze. It is a big change, I assure you. Papa is still the same, but I hardly know the rest of the family. René is a young man, and he is very tall for his age. My two sisters fill me with respect, and I feel awfully diminished. I hope your trip [Moreau had been to Rome] went as well as mine. I did not mean to distress you so by going to the [train] station that morning; I realized that you were right to prevent me from doing so. The following day I even implored my aunt not to leave the house. Poor woman! That was a hard moment. She tried to keep me from leaving the same day because of the wind. But I could no longer stand the pangs that had been nagging at me for several days. I reached Livorno, but no boats were leaving on account of the weather. I had to spend the night. The following day I went aboard a little Sardinian boat that brought me to Genoa in fairly good time, about six in the evening. The boat was full of volunteers, more than a hundred of them. I can assure you that there was no more swagger and that those poor lads were confident about what they had set out to do.

Genoa: What a beautiful and superb town! What beautiful Van Dycks! Go to the Palazzo Brignole if you return by way of Genoa and take a good look at the [picture of the] Countess Brignole alone, then [the one of] a lady of the family with her daughter, the Veronese, and the portrait of a Venetian lady, all in light tones. No one has ever equaled Van Dyck for capturing the grace and guile of women, the elegance and gallantry of men, or the distinction of them both. There is more to this great genius than natural aptitude, my dear friend, as you said to me one day. I suspect that very often he pondered his subject and let it sink in the way a poet does. Whether it was the place, which was so conducive to illusion and still cherished its former masters, or because I had died a little ahead of time, I cannot tell; but I had an hour of real enthusiasm there.

There is a fine museum in Turin. I don't care all that much for the large Veronese. You will see a head of Philip IV by Velázquez and a number of Van Dycks, some more highly thought of than others, but all equally beautiful to me. Do you remember the time you agreed with me, when I told

W̲hen in Rome: Notes and sketches Degas made on his Italian trip.

you that we loved a certain painter's temperament so much that we always found his ideas, good and bad alike, equally captivating? My guidebook informs me that there is a palazzo on the banks of the Po known as the Castello del Valentino, built by Christine, the widow of Victor Amadeus I and daughter of Henry IV and Marie de Médicis. It stands amid trees, all by itself. Tell me if that doesn't look like the palazzo of a widow, melancholy after a brilliant youth, often gazing at the snow-laden Alps that stand between her and France. I sat down on the grass, as I was rather tired from running all over town since morning, and drifted into the reverie you know about. I must say, the setting was very conducive to it.

I crossed over Mt. Cenis at night. Once I reached the other side everyone spoke French. I was in Savoy and almost home. I left St. Jean de Maurienne at half past noon; from the snow I proceeded to the Lac du Bourget, where, according to my guidebook, Rousseau once lived. I was in Mâcon at half past seven. At half past six in the morning I was in Paris and by seven o'clock I was waking up the whole house.

I've already seen [Antoine] Koenigswarter several times; he is waiting for you with growing impatience. I tried a little to come to your defense. He would like to see you exhibit next time. The day before yesterday the two of us went to the exhibition [the Salon of 1859]; he had

arranged to meet [Eugène] Lacheurié there, and I was very pleased to make his acquaintance. You know how highly you spoke of him to me, and I myself felt quite the same after chatting with him a while. We talked a great deal about you.

There probably will be a war. Staying in Rome poses absolutely no danger to you and your family. Wait a little and see how things turn out before you venture a trip to Naples. The king [Ferdinand II, king of the Two Sicilies] will be dead soon, if he isn't already. If there is a revolution, it will be a very

T*wo Nudes*. Pen and black ink.

short and very peaceful one. Don't lose your temper; you'll be amazed at how well things are going to turn out for you.

I should have already told you that I saw [Frédéric Charlot] de Courcy several times. You can certainly take pride in having such a staunch friend. He is well. His painting is much better than I expected. It shows a marked affinity with Poussin.

Lévy is well. I only got to see him once. He is doing ceilings at the Hôtel Purbado in Paris.

[Eugène] Fromentin has almost walked away with the exhibition, in my estimation. Unfortunately, whenever he tries to tighten up his execution, it becomes more heavy-handed. There is a *Negro Mountebanks* and an *Edge of an Oasis During a Sirocco*, both masterpieces. Next to them everything else looks like brown sauce.

Remember me to your estimable parents.

Write to me at 4, Rue Mondovi when you get a moment. I'm going to write to Tourny [painter in Italy working on a commission for collector Louis Adolphe Thiers], even though he hasn't written me back. Congratulate him on his exhibition. What a shame that M. Thiers did not allow his large drawing to be shown.

I embrace you. Every good wish to Delaunay, Bonnat. Lamothe is sillier than ever.

E. De Gas

TO LORENTZ FROLICH
[undated: 27 November 1872]
Only today, Nov. 27, did I receive your affectionate letters, my dear Frölich [painter and designer]. These accurate Americans read Norwick (Connecticut)

where your pen had clearly written "New Orleans." If this kind paper traveled about a fortnight too long, they are to blame.

The ocean! How big it is, and how far I am from you! I sailed on the *Scotia*, a sure and swift English ship. It brought us (my brother René and me) from Liverpool to New York in ten days; even the *Empire City* takes twelve. What a sad crossing it was! I did not know any English and know hardly any more now, and on English territory, even at sea, there is a coldness and conventional distrust that you yourself may have already sensed.

New York: a great city, a great port. The townspeople know their sea. They even say that going to Europe is going to the other side of the sea. A new breed of people. In America people are far less mindful of the English race than I suspected.

Four days by train brought us here at last. Borrow an atlas from your dear little daughter and look at the distance. Well (I certainly do not have the strength of Thor), I was fatter than when I started out. Air, there is nothing but air. All the new things I saw, my dear Frölich! All the plans they filled my head with! I've already given them up; all I want now is to see my little corner of the world and burrow there diligently. Art does not branch out, it concentrates. And if you must have comparisons at all costs, I'll tell you that to bear good fruit you need to be tied to an espalier. Spend your whole life there, arms outstretched and mouth open, so as to assimilate what is happening around you and draw life from it.

Have you read Jean-Jacques Rousseau's *Confessions*? No doubt you

Study of Sailors.

have. Well, do you recall the way he described his flightiness after he fled to the lake island of St.-Pierre in Switzerland (toward the end), how he would go out at daybreak and, whichever way he went and without realizing it, he would scrutinize everything and start projects that would take ten years to finish, only to drop them ten minutes later without regret? Well, that is precisely the case with me. Everything attracts me here, I look at everything, I shall even give you an exact description of it all when I get back. Nothing pleases me more than the black women of all shades, holding little white children, so very white, in their arms, against white houses with columns of fluted wood and in gardens of orange trees, and ladies in muslin against the fronts of their little houses, and steamboats with twin funnels as tall

as factory smokestacks, and fruit vendors with stores filled to overflowing, and the contrast between the bustle and efficiency of offices and this vast dark animal force, etc., etc. And the pretty pure-blooded women and the pretty quadroons and the strapping black women!

So, I am accumulating plans that would take me ten lifetimes to carry out. In six weeks' time I'll have dropped them, without regret, and return to *my home* [*sic*], never to leave it again.

My dear friend, I cannot thank you enough for your letters and your friendship. They are so very welcome when one is so far away.

My eyes are much better. I am doing little work, it is true, but what I am doing is difficult. Family portraits must be done pretty much to suit the family, by impossible lighting, with constant interruptions, and with models that are full of affection but a little forward and who take you far less seriously because you are their nephew or cousin. I've just botched a big pastel, not without mortification. If I have time I intend to bring back an unfinished little something or other, but for myself, for my room. One mustn't do Parisian and Louisiana art indiscriminately; it's liable to end up looking like the *Monde Illustré*. Besides, only a really long stay can give you an idea of the customs of a people, that is, their charm.

Momentary exposure is photography, nothing more.

Did you see that Mr. Schumaker you

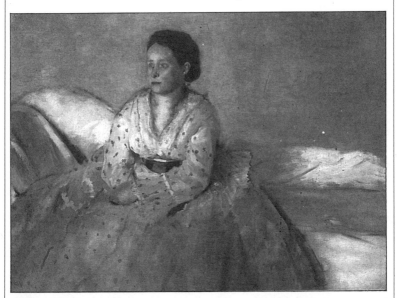

M*me. René De Gas*, 1872–3.

referred to me? He thought I could have more easily done what he asked of me. He wanted to get rubbed down by a French hand, the way they do it at the Turkish baths, right after having sweated a little. I told him it took time to sweat out our (therapeutic?) vices.

I'll probably be back in January. I shall sail by way of Havana. But you'll be leaving us soon, you say? It is for your aged mother's sake, I take it, in which case it is a duty. Anyway, we shall see a lot of each other until the spring. Your little daughter will play for me, I need music so badly. There is no Opera here this winter. Last night I attended a rather pathetic concert, the first of the year. A Mme. Urto played the violin capably, but with sorry accompaniment, and concerts have no intimacy, especially here where people applaud even more stupidly than elsewhere.

Clotilde must have been thrilled to fill you in on Monsieur's trip. No doubt she did not spare you her opinions. She is a regular servant out of a play, but she has her good points. I threatened not to take her back when I returned, and I dread doing it. She is too young for a bachelor and really does come across as too cheeky. You must still have your Swedish girl; she seems so attached to you, you won't be able to part with her.

You only met Achille, and only in passing, I believe. My other brother, René, the youngest of the three boys, has been my traveling companion, indeed, my lord and master. I didn't know any English or the art of traveling in America; so I have been following him blindly. What blunders I'd have committed without him! He is married, and his wife, our cousin, is blind, poor thing, and almost without hope. She has borne him two children, a third is on the way (I am to be the godfather), and, as the widow of a young American killed in the Civil War, she already had a little nine-year-old girl of her own. Achille and René are partners; I am writing to you on their office stationery. They are earning a respectable living and financially are in unusually good shape for their age. They are well liked and well thought of, and I am proud of them as I can be.

Politics! I am trying to keep track of what is happening back in France in the Louisiana papers. Practically all they talk about is the building surcharge, and they give M. Thiers expert advice on republicanism.

Goodbye, your proverbs are as plentiful as those of Sancho; had you his high spirits, you would increase them threefold. How healthy laughter is; I laughed at them a lot.

It's true, my dear Frölich: One does feel young in spirit. That is what David said in Brussels just before he died. But one is bound to lose a little of one's zest, cheerfulness, and eyesight. You are in better shape than I am.

You may write to me when you get this; your reply will still find me in Louisiana. A kiss for your little one. I clasp your hand and thank you for your friendship.

Degas

Regards to Manet and his family.
I have reread my letter. It is very cold next to yours. Don't be cross with me.

"A Visit with the Impressionists," cartoon from *Le Charivari*, 9 March 1882.

UNE VISITE AUX IMPRESSIONNISTES

PAR DRANER

TO CAMILLE PISSARRO
[undated: 1880]

My dear Pissarro,

I congratulate you on your mettle. I rushed to Mlle. Cassatt's with your parcel. She joins me in complimenting you on them.

Here are the proofs. The overall blackish or rather grayish tone is due to the zinc, which is inherently greasy and retains the printer's ink; the plate is not smooth enough. I suspect you do not have the same facilities for this at Pontoise as you do on Rue de la Huchette. Just the same, you need to use something smoother.

At any rate, you can see how promising this process is. You'll also have to practice graining the surface in order to obtain, for instance, a uniform and evenly gray sky. It is no mean feat, to hear Maître Bracquemond tell it. But it might be fairly easy if you intend to limit yourself to prints after original art.

Here's how it's done. Take a really smooth plate (this is essential, you understand). Remove every bit of grease with whitening. You will have already prepared a solution of resin dissolved in highly concentrated alcohol. This liquid—poured the way photographers pour collodion onto their glass plates (being careful, as they do, to tilt the plate and let it drain thoroughly)—this liquid will evaporate and leave a coating, more or less thick, of tiny particles of resin. As the plate is bitten, you are left with a grained effect of varying darkness depending upon the depth to which you allow it to bite. This is what you must do if you wish to obtain uniform tints; for less regular effects, you may use a stump or your fingertip or any other kind

of pressure on the paper covering the soft ground.

Your soft ground is a little too greasy, it seems to me. You added a bit too much grease or tallow.

What did you blacken the ground with to get that sepia tone for the background of the design?

It is very pretty.

Try something larger with a better plate.

As far as color goes, I'll have the next batch you send printed with colored ink. I have some other ideas for colored plates.

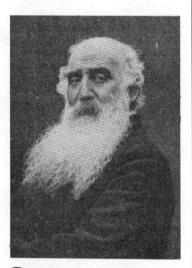

Camille Pissarro.

Also, do try something more *finished*. It would be delightful to see the outlines of the cabbages crisply defined. Bear in mind that you must start out with one or two truly beautiful plates of your own work.

I am going to get down to it myself in the next few days.

[Gustave] Caillebotte is doing the *safety islands of the Boulevard Haussmann* from his window, or so I'm told.

Could you find someone at Pontoise who might be able to cut very thin copper into pieces traced by you? You could lay stencils like these on a line proof—touched up a little for this purpose—of a hard- or soft-ground etching, and then print the exposed areas with porous wood coated with watercolor. This way you could experiment with printing really original and unusual things in color. Work on that a little if you can. Soon I'll send you some of my own efforts along these lines. It would be economical and new. And I should think that would do for a start.

No need to compliment you on the artistic quality of your vegetable gardens.

Only, as soon as you feel a bit more comfortable with it, try something on a larger scale, and try giving your work more finish.

Don't lose heart.

Degas

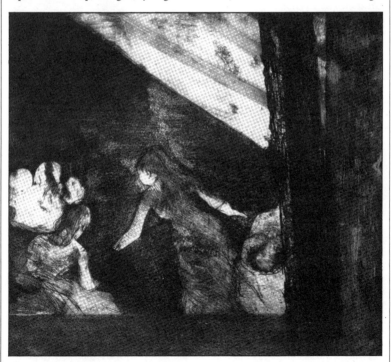

A t the Café des Ambassadeurs, 1879–80.

TO HENRY LEROLLE
4 December [1883]

My dear Lerolle, go at once to hear Thérésa at the Alcazar, Rue du Faubourg-Poissonnière.

It is close to the Conservatory, and better. A long time ago, someone already said—what man of taste I do not know—she should have a go at Gluck. All of you are immersed in Gluck at the moment. [Degas attended the recitals of *Orfeo* then being given at the home of composer Ernest Chausson, Henri Lerolle's brother-in-law.] Now is the time to go and hear this admirable artist.

She opens her large mouth and out comes the wittiest, most delicate, most naturally tender voice you ever heard. And the soul, the good taste—where could one find better? It is superb.

In any case, see you Thursday at *my* musician's.

Regards,

Degas

TO ALBERT BARTHOLOME
Wednesday
[undated: 1883, the year
Manet died]

A change of surroundings must be doing you good, even in this beastly weather. It's bound to be curing you of not being warmed all day by a stove—and also by painting. Now that the days are getting longer, I must make it a strict rule not to spend more than half the day in the studio—either morning or afternoon—and to go for walks. Here is a new motto: *Ambulare postea laborare.*

Manet is a goner. They say that that Dr. Hureau de Villeneuve poisoned him with tainted rye flour.

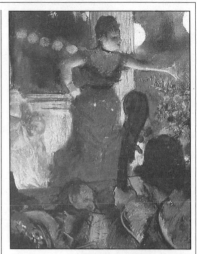

Café-Concert at the Café des Ambassadeurs, 1876–7.

Some newspapers, they say, have already taken it upon themselves to inform him of his impending demise. I do hope his family will have read them before he does. He has no inkling of the condition he is in, and he has a gangrenous foot.

TO ALBERT BARTHOLOME
16 August [1884]

You are going to proceed by way of confiscation, my dear friend? What would you confiscate in the horrible human heart? I don't know where my friends can sit in it, there are no chairs left. There is the bed, which cannot be confiscated and where I really do spend too much time sleeping. At seven o'clock this morning, after leaving it for a moment to go and open the window and start writing to you before the postman stopped by, I stayed there to enjoy the morning more thoroughly.

Yes, I am getting thoughtless, and in a comatose state that makes this disorder irremediable. Having cut art in two, as you remind me, I'll cut off this fine head of mine and Sabine [Sabine Neyt, one of Degas' housekeepers] will preserve it in a jar for its shape's sake.

Is it the countryside, is it the weight of my fifty years that makes me feel so burdened, so sick at heart? People think me cheerful because I smile idiotically, resignedly. I am reading Don Quixote. Oh, fortunate man and what a glorious death!

As she enjoys such excellent health, let your wife not curse me too much and let her ask herself if I am really worth the trouble. Let her save her anger and her tenderness for a man who is young, confident, proud, simple, bold, and meek, supple and hard, painter and writer, writer and father, and even more astonishing than he thinks, writes, or lets others write, and says so: Long live J[ean-] F[rançois] Raffaëlli. That's the man we need, believe you me.

I ought to be incensed by your medal. And I applaud it as if it were made of gold. Long live Sandoval, too, the man of leases, the man who pays his rent and acknowledges your worth that way and no other.

Here I am cracking crude jokes, and I do not care to. Oh, where are the days when I thought myself strong, when I was full of logic, full of plans! I am quickly sliding downhill, rolling I know not where, wrapped up in lots of bad pastels, as if in so much packing paper.

Good-bye, and kindest regards anyway to you and your estimable wife.

Degas

TO ALBERT BARTHOLOME
Ménil-Hubert
Monday [15 September 1884]

The little balm, made with your own hands, my dear friend, found its way to me—I rubbed some on and cannot deny that it did me good. But it was a close call.

If you'd like me to tell you why I am still here, I shall do so: "So, you're not doing anything of Hortense

Edgar Degas.

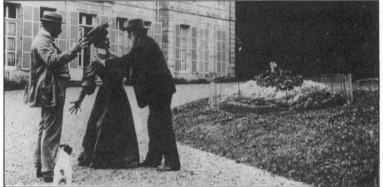

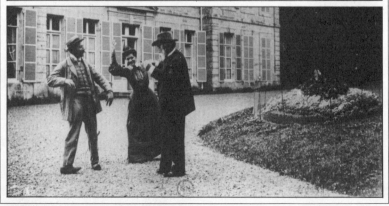

[Valpinçon]?" her mother said to me. "And just who do you suppose will?" To keep myself busy I started working on a large bust with arms, fashioned from clay mixed with little pebbles. The family is following my work with more curiosity than emotion. In short, when one is as out of kilter as I am, one amuses oneself only with things one cannot do. And aside from the fact that I can hardly stand on my own two legs, and that my arms are straining my stomach from too much stretching, things are going pretty well. I shall certainly be back in Paris around the end of the week, and after some time spent on earning my keep, I shall have to return to Normandy with a molder to make a cast and see to it that the work is durable. The family is helping out and will continue to do so, like Norman peasants, doubt etched on their faces and deep in their hearts.

TO PAUL DURAND-RUEL
Ménil-Hubert
Summer 1884

Dear Sir,

My housekeeper will go and fetch a little money from you. This morning she sent me the confiscation warning from the Revenue authorities. I had paid more than half. It seems the government wants the balance at once. Fifty francs will do. But if you could see your way to giving her a hundred, she could keep something for herself. I did not leave her with very much, and I am prolonging my stay here a while, the

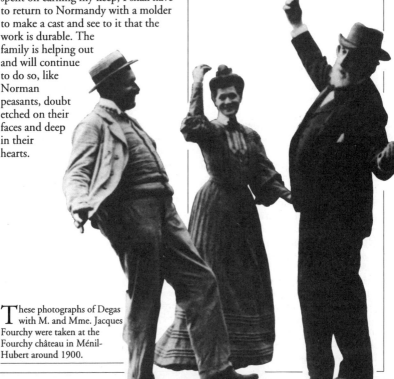

These photographs of Degas with M. and Mme. Jacques Fourchy were taken at the Fourchy château in Ménil-Hubert around 1900.

weather being so nice.

Oh, well! I'll load you down with goods this winter, and you'll load me down with money.

It really is too annoying and humiliating to run the way I do after every little 100-sou piece.

Kindest regards,

Degas
Château de Ménil-Hubert
near Gacé (Orne)
Wednesday

TO ALBERT BARTHOLOME
[undated]

It is here, I looked at it again this morning, with its *buttock-folds over its red loins.* That is how Goncourt thinks and writes when his friend Bartholomé sends him a pumpkin.

We shall have it Sunday for supper, my dear friend, myself and a few other people who care for Opera, and who know about food. I shall try not to eat more than they do, even less.

When *are* you coming back? I am asking you that and forgetting you love the fields and have a thing for gardens, and that one day that is where I shall go to place a Wagnerian slab above your head. I am therefore the bear [an allusion to La Fontaine's fable], holding gentle sway over modern sculpture, more given to sucking the honey of the Hymettus in the opera *Sigurd.* I saw *Sigurd* again and just missed seeing Reyer again at the Brasserie Muller, to the right of the monument. Divine Mme. Caron—speaking to her in person I compared her with the figures of Puvis de Chavannes, which were unknown to her. The rhythm, the rhythm—may your estimable wife give it back to me one day soon in front of

Rose Caron, c. 1892.

the infamous Reyer, who rules over his score!

That pumpkin was crisply delineated, wasn't it? Oh, if only one could draw noble hips, round shoulders like that! For lack of grownups who refuse to let themselves be seen (Sabine), there are children built like that.

I dropped your sister-in-law a line. Remember me to her again. Kindest regards to you both. You might write about something other than vegetables; I'd enjoy that, too.

Sincerely yours,

Degas

Wednesday: Any news?

TO ALBERT BARTHOLOME
Cauterets, 19 August 89
Monday

Henri, Baron d'Ernemon, age 65, the person on my left at the table, had at me after the person on his left had gotten up. Despite all the huge pieces [of food], especially the chunks of roquefort, he imparts his every thought to me without letup. And he thinks like Arnal about any subject you choose. It

drives me to tears and he enjoys watching this happen on account of him. He inevitably drops the names of all the people he has known. Such and such happened to him near his château in Neuilly, between Pacy-sur-Eure and…while talking to the younger Mme. de Boisgelin, Mlle. de…, something else happened with a whore from Amiens. For all that, he's a very good-looking man, and his sturdy shoulders have borne a worthless life. He was a close friend of Janvier de la Motte, his monitor of course. You cannot not know, even through M. de Fleury, what this beastly fellow is all about. "Here's another good one. If you know it, you stop me." You would have to be a policeman to stop him. I run into him in a corner of the refreshment room, and he is always the first to open fire. He has tact, though. He took leave of me after lunch, set me aside; he knows his audience.

The person on my right, Langlès, the big biscuit manufacturer, is certainly a more substantial sort than the baron. Did I tell you he used to live on Avenue Kléber, that he had lost his older little girl, left Paris out of sorrow and moved his family to an estate in Pau as he himself had to go to his factory down there every winter? He even used to go and draw after the model at the Académie de Colarossi, where Courtois, Blanc, Dagnan-Bouveret, or Flameng would correct his work. I had to tell him that I was a painter and that did not alarm him.

I am writing to you, M. Bartholomé, even though it is 5:30—strolling time—because it is raining cats and dogs. I also think I deserve one or more good letters to amuse me while I wait for it to end. I know that Mme.

Howland and her pianist called on you and admired and envied your passion for art and for work. And with good reason, I must say.

Forain once did a drawing of Mme. Prudence. Surely you remember it. I can visualize it, but the title escapes me. She has a way, does she not, of making you set your heart on the future without knowing a blasted thing about it. But the even simpler fact is that one is in that position oneself.

I am still thinking about a trip to Madrid and a real bullfight. Should I send for that flashy foreigner Boldini? Will Lafond tag along? Will I myself have the nerve not to return at once to Paris and spare my life further danger? Alas, I still have thirteen days to go and time to remain undecided.

But I nearly deprived you of the pleasure of learning that Haas may arrive in eight or ten days, and that the tack he takes toward me, to see me or cut me off (like a corn in the Rue de la Paix), either will cost him or it won't. He knows that I do not see, and that when I do, I don't care either way. Will he have a plan and the nerve to follow it through? You know how funny ladies' men are with other men.

Have you and the engineer Manzi, the rich collector, gone to the Invalides to see the water railway? Do try, and tell me about it.

Regards to the Fleurys (of the sea) and to your Italians. Don't do too much of that sculpture before I get back.

"Blasted weather!" I said to the baron; his immediate reply: "I prefer it to the guillotine."

Yours,

Degas

TO EVARISTE DE VALERNES

Paris, 26 October [1890]

I have been thinking constantly about you with the most affectionate feeling, and I have not been writing to you, my dear de Valernes.

Your lovely letter caught up with me in a little village called Diénay, in the Côte-d'Or [region of Burgundy], where Bartholomé and I were brought by the following adventure.

After Geneva, I no sooner left you than met the said faithful friend at Dijon; from there we went to the said Diénay to call on the Jeanniots, who spend a third of the year there; and after leaving them, and once [I was] back in Paris, the memory of this delightful spot and the desire to get a better look at superb Burgundy worked me up to such a state of excitement about traveling that I talked my good comrade into sharing my obsession.

This obsession—now considered by us and by others as something particularly wise—could only be appeased by leasing a tilbury and a white horse and covering more than six hundred kilometers...in twenty days, five of which we spent resting in Diénay.

When summertime is upon us once again, we shall start over with a different horse (that one was too weak in the forelegs), the same kind of carriage, and perhaps go all the way to the Rue Sadolet to stir that old heart of yours once more, to get another look at your philosopher's house, your museum, the room you use for drawing, to introduce you to Bartholomé, who has so often heard me speak of you and your energetic, sensitive life. All this is going to alarm you. But you won't have the heart to tell me that it frightens you. We could leave or not leave the animal at the Hôtel de l'Univers and drag you with us to Avignon to see your St. Thérèse (she is in the Museum, isn't she?), talk about Delacroix and about the art we are duty-bound to practice, that is, whatever can bewitch Truth and give it a semblance of Madness.

I can picture you and your little studio, which I may have given the impression of looking over too quickly. I can see it as though it were in front of me.

I can even tell you that seeing it this way added almost nothing more distinct, for I had not forgotten any of it, and it reminded me of your two phases of life (less clear-cut than you think and than I, too, used to think).

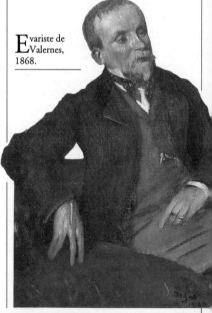

Evariste de Valernes, 1868.

You have always been the same man, my old friend. In you there has always abided that delectable romanticism which clothes and colors Truth, and lends it that fitting air of madness I just mentioned.

Here I must beg your forgiveness for something that often crops up in your conversation and still more often in your thoughts: that I have been, or seemed to be, in the course of our long relationship as artists, *hard* on you.

I have been particularly so on myself: surely you are aware of that, since you saw fit to to reproach me for it and seemed surprised that I had so little confidence in myself.

I was, or seemed to be, hard on everyone out of a kind of conditioned brutality that stemmed from my uncertainty and my bad humor. I felt so ill-constituted, so ill-equipped, so weak-willed, whereas my calculations about art seemed to me to be so right. I took it out on everyone, myself included. I beg your forgiveness if, on the pretext of this confounded art, I have done harm to your very fine and intelligent mind, perhaps even your heart.

That picture of the *Malade*—I can visualize not only its general effect and simple mood of sorrow, but the least little brushstroke and the execution (à la Duranty, as it were)—is a fine picture.

The composition with the two women of Arles, the way they are grouped, is delightful.

Again I found the same fortitude, the same strong, steady hand, and I envy you your eyes, which look as though they will let you see everything till your dying day. Mine will not

give me this joy; I can barely read the papers a little, and when I get to my studio in the morning, if I have been so foolish as to linger a while over this deciphering, I am unable to get down to work.

Remember, you must count on me for company when the time comes. Write to me.

I embrace you.

<div style="text-align:right">Degas</div>

Remember me to M. Liébrastes and also to the charming Salla.

TO HENRI ROUART

<div style="text-align:right">Sunday [undated]</div>

All the same, tiresome or difficult though it may be for me to write, I will not leave you without an answer, my dear old friend. And so the poor wandering Jew has passed away. He shall walk no more, and, had there been some advance warning, one surely would have walked a little behind him. What was on his mind ever since the filthy *affair*, and what did he think about the embarrassment people could not help feeling in his presence? Did he ever say anything to you about it? What went on inside that old Israelite's head of his? Did it even occur to him to think back on the days when we knew almost nothing of his terrible race? We'll speak of this again when next I see you.

Wednesday I went to La Queue, and I told them about a strange dream I had two days after learning of his death at Tasset's. Fancy that I ran into him, with a bit *more hair on his head*, and as if I were awake, I had the presence of mind to stop myself just as I was about to say to him, "Why, X…, I thought you were dead." So, we remember even as we dream.

Degas As His Contemporaries Saw Him

Degas was not given to baring his soul and kept a close watch over all aspects of his private life, revealing little, even to members of his immediate circle. Since his lifelong friends—Paul Valpinçon, Ludovic Halévy, Henri Rouart—wrote scantily or not at all about him, we must rely on the accounts of younger intimates who knew him only late in life.

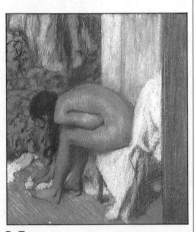

N*ude Woman Drying Her Foot,* c. 1885–6.

Two Hours with Degas

Painter, collector, and art historian Etienne Moreau-Nélaton (1859–1927) is chiefly remembered for a superb collection of Impressionist paintings— including its undisputed jewel, Manet's Le Déjeuner sur l'Herbe *(Musée d'Orsay)—which he bequeathed to the Louvre in 1906. His writings on art, in particular,* Manet Raconté par Lui-Même *(1926), remain authoritative sources to this day.*

Thursday,
26 December 1907

On my way back from Hériot's (my picture framer), I stopped by M. Degas' on Rue Victor-Massé. I was bringing him an album prepared expressly for him, which contained a photographic facsimile of Delacroix' travel journal, the one Burty bequeathed to the Louvre. It was four o'clock. I climbed up the three flights and rang the bell opposite the staircase. That was the door to the studio. It opened a little and the master of the house, a maroon hat on his head, looked at me with unseeing eyes. I identified myself. "Ah, Moreau! Do come in. But watch out for that dressing gown. Don't mess up its folds, poor thing!"

A piece of salmon-pink fabric was POSING on the corner of a chair, next to a bathtub: another model for the pastel the worker had been fencing with all day long. And there it was, pinned to a piece of cardboard because it had been done on tracing paper. It showed a young woman emerging from her bath, with a maidservant in the background. The foreground was filled with the precious pink

fabric that was not to be messed up.

The execution was a trifle sketchy, as was everything done at the time by this man whose eyes were growing weaker by the day. But what robust and magnificent draftsmanship! The hand, gripping the straight edge of an otherwise unseen bathtub, was superb. While my eyes were glued to this picture, M. Degas relieved my hands of the book I had brought him. He started to leaf through it, but night was fast falling. We are almost in the dark. He put the thing down, and presently he left Delacroix for the man who had been his most fervent admirer, namely, Robaut.

A few days earlier, what remained of his collection had been dispersed to the Hôtel Drouot. "I went there," said my host, "in hopes of picking up some LITTLE ARTICLE or other. I upped the bidding for Delacroix' little BABOUCHES to 120 francs. Preposterous. I had to withdraw. That collector who is always buying for the Friends of the Louvre—he was the one who snatched them from me with a bid of 125 francs. Anything by Delacroix has become prohibitively expensive! Louis Rouart intended to buy the drawing of the LUTTEUSES; he expected to go as high as 1200 francs; it fetched 1500. Preposterous. Way back when, that could have been had for 50 francs."

"The Louvre was on good behavior," I pointed out. "It purchased Corot's BELFRY [of Douai]."

"True, but I'm not sure I care all that much for it."

"You don't mean it!"

"Now, I myself would rather have had the MONTE CAVO. Those black mountains swept me off my feet. Come

to think of it, Robaut seems to have gone completely dotty. No longer will he be heard whining about his PAPA COROTS and his PAPA DUTILLEUXES! What a revolting junkman!" I insinuated that dealers of his ilk were legion nowadays. "True," I heard the fervent collector reply. "There are no more disinterested collectors like you and me. People regard us as imbeciles."…

But the conversation had changed course. At issue now was the hectic life we were leading in a feverishly paced society. "Speed!" I heard a voice exclaim. "Is there anything more stupid than speed? People will tell you matter-

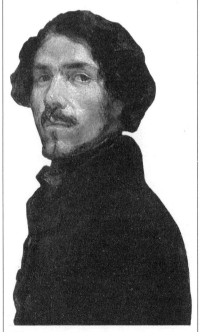

Eugène Delacroix, *Self-Portrait,* c. 1842.

of-factly: In two days' time you must know how to draw…. But absolutely nothing gets accomplished without the patient collaboration of time." The man across from me was angry. This anger was now directed at landscape painters who work FROM NATURE, as if conventions were not the lifeblood of art.

"Don't talk to me about those bright-eyed bushy-tailed fellows who clutter the fields with their easels. I wish I were a despotic tyrant with the power to arm a police force and order them to shoot without mercy, like so many noxious animals, those wretches who lurk in the shrubbery behind their stupid white canvas shields."

While this verbal outburst was in progress, his hand had reached out toward a table where, among pastels, palettes, and papers, a little white earthenware cup was waiting for lips to strain toward its rim. M. Degas fell silent and took little swallows. He stopped. "You know what this is?" he asked. "Milk?" "No, cherry-stalk tea. A diuretic. Alas, I have been reduced to this: This bladder of mine has lost its elasticity. I have to get up five or six times during the night. What misery. What's more, like it or not I've got to put these old legs of mine through their paces every day before dinner."

The time had come for the invalid to leave the premises and start walking through the lighted city. He agreed to let the hackney cab that brought me, and which I had left waiting downstairs, take us to the Rue Guénégaud to see old Lésin, who does his mounting for him. He would return on foot; that would

be his constitutional. Darkness had completely engulfed the studio. He lowered the blinds while I fumbled my way between the easels and scattered bric-a-brac until I reached the door, where he met me.

A brief stop at the floor below, where his living quarters are. He walked into his bedroom to put on his shoes and an overcoat. As he got dressed, he grumbled about how burdensome his rent was. "Six thousand francs, and taxes to boot; it's overwhelming, I tell you." I scanned the drawings on the wall, around the fireplace. My eyes came to a sketch by Ingres, I asked which painting it had been done for. "What's that? Why, the ILIAD."

"What about this figure here over the bed?"

"That one was for THE GOLDEN AGE."

There was another study for the TU MARCELLUS. My host reached for the lamp and held it up close to show it to me. Farther back, a painting by Gauguin alongside a small sketch by Suzanne Valadon. Elsewhere, some watercolors of armor by Delacroix. The bed had already been turned down for the night: a fairly roomy iron bedstead with the head screened off. As we exited through the adjoining room we paid our respects in passing to the [BARON] SCHWITER by Delacroix, the PASTORET by Ingres, and a copy after Rubens by Delacroix. My companion paused in front of it. "You know," he said, "Delacroix left that with Mme. Sand." Before we crossed the threshold our parting glance was for Gauguin's copy of the OLYMPIA.

The carriage headed down Rue

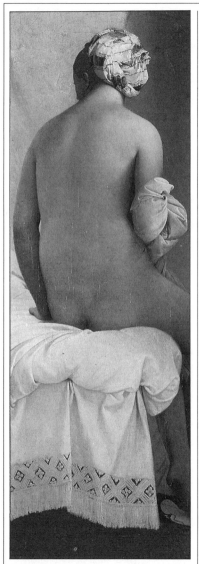

Jean-Auguste-Dominique Ingres, *The Valpinçon Bather* (detail), 1808.

Pigalle and along the Chaussée d'Antin. It reached the Seine. M. Degas filled it with his conversation. He talked about the sons of his friend Rouart; about Louis, who was taking up ART CRITICISM. The occupation elicited a shrug.

"Art critic! You call that a profession? To think that we painters are stupid enough to solicit these people for compliments and to put ourselves in their hands! For shame! Should we so much as give them leave to speak of our work? As if the Muses did not set an example by working in solitude! ALONE AND ABSORBED IN THOUGHT! That is how Antiquity depicted them. If they happened to assemble, it was by no means to converse: conversation degenerates into argument. They did so in order to dance, and did not convene otherwise...."

We reached the Rue Guénégaud. M. Degas walked into the shop of "his friend" Lésin. "Come along," he said to me. "I'm going to introduce you to this estimable man." This formality behind us, he unrolled the drawing he had been holding in his hand. He fixed his pastels with a fixative that Chialiva had given him and which was kept SECRET. All the while we were in the carriage, he talked to me about now-lost SECRETS of painting that were unknown even to Delacroix. To hear him tell it, "An old spinster Van Dyck knew in Genoa passed along secrets that Titian had confided to her."

The creator of the pastel presently unfurled on the mounter's table wondered whether a few centimeters shouldn't be trimmed from the bottom. He hesitated. Then…"Two centimeters, fine, no more." He asked

me for my opinion. I voted for leaving it just as it was. "Only look," he said right away. "The maidservant's head is so close to the upper edge. We need to take a little off the bottom. Otherwise, there's no balance." I gathered from his comments that the drawing spread out before me was just a preliminary study. Once MOUNTED, it would be more convenient to work it into a something finished. The fixative caused the colored powder to bond securely to the underlying paper. To convince myself, a brisk rub of the fingertip against the pastel: It stood up to the test.

My hand was on the doorknob and I was getting ready to take leave of my companion. "Wait!" I suddenly heard a voice shout. "I'm not letting you go just yet. I'll go back with you as far as your place. From there I'll go home on foot." The cab continued on its way. We rode along the Quai Voltaire. M. Degas leaned against the window, which he had closed because of the biting cold. He was looking at Ingres' studio. What he saw reminded him of the time he was there, and before I knew it he was recounting that distant memory. "It was in 1855. A friend of mine, the elder Valpinçon, owned the ODALISQUE WITH A TURBAN: you know, the upright one with her back to you. Well, one day I called on him.

'I saw your God yesterday,' he said to me. 'That's right, M. Ingres was here to see if I would lend him my ODALISQUE for the exhibition of his work they were planning to put into that clapboard hovel [at the Paris Exposition]. Well, I made it clear that I was not prepared to jeopardize my painting. I turned him down.' I told Père Valpinçon that I

Paul Valéry.

found his selfishness appalling, adding that one did not slight a man like M. Ingres. I vented my indignation with such intensity that I left him looking ashamed and relenting. 'Very well,' he said. 'Tomorrow I'll tell M. Ingres I've had a change of heart. Call for me. We'll go to his place together.' The next day I kept my appointment punctually. M. Valpinçon and I reached the Quai Voltaire. We went up to the door, rang the bell, and THE MONSTER APPEARED. My old friend apologized for his meanness. Then, after introducing me, he announced that it was thanks to me that he had changed his mind and decided to lend the painting in question after all."

Etienne Moreau-Nélaton
(published posthumously in
L'Amour de l'Art,
July 1931)

In 1893 André Gide introduced Paul Valéry (1871–1945) to Eugène Rouart and soon afterward to Rouart's brother Henri. It was at Henri's house that he met Degas, who quickly became one of his close friends. The bond between Valéry and the Rouart-Degas circle strengthened in 1900 when Valéry married Jeannie Gobillard, whose mother, Yves (Berthe Morisot's sister), had sat for a Degas portrait in 1869. Valéry wrote about Manet and Berthe Morisot and in 1936 published the seminal Degas Dance Drawing, *an incisive analysis of Degas' work interspersed with conversations he had had with the artist.*

37 Rue Victor-Massé

This unpretentious studio occupied the fourth floor of the house on Rue Victor-Massé that Degas lived in when I first met him. On the second floor was hung his *Museum*, which consisted of a few pictures he had acquired through exchange or purchased outright. On the third was his apartment. He had hung on the walls his favorite artwork, his own or other people's: a large, very fine Corot; pencil drawings by Ingres; and a particular study of a dancer I coveted every time I saw it. He had not so much drawn it as actually constructed it joint by joint, like a jumping jack: an arm and leg sharply bent, the body stiff, the linework implacably controlled, here and there a few highlights in red.

In this third-floor apartment was the dining room where I endured many a dismal dinner. Degas had a fear of intestinal obstruction and inflammation. The unembellished veal and the macaroni boiled in plain water,

which old Zoé served us very slowly, were perfectly flavorless. One was also expected to ingest a certain Dundee orange marmalade which I considered unbearable at the time but grew to tolerate and no longer find so loathsome *because of its associations*. Now if I have occasion to taste this puree shot through with carrot-colored fibers, I can see myself sitting opposite a frightfully lonely old man absorbed in mournful thoughts, deprived by the state of his eyesight of the work that was his entire life. He offers me a cigarette as hard as a pencil and I roll it between my palms to make it smokable; this stunt intrigues him every time I do it. Zoé brings in the coffee, leans her great belly into the table, and chats. She speaks very well; it seems she was once a schoolteacher. The huge round spectacles she wears lend her broad, frank, invariably serious face something of a scholarly air….

As for Degas' room, it was in the same state of neglect as the others, for everything about this house bespoke a man who now clung to life itself and nothing beyond that, and because one does so in spite of everything, in spite of oneself. There

P<small>aul</small> Valéry.

was an odd piece of Empire or Louis-Philippe furniture. A dried-out toothbrush in a glass, its bristles half-tinged a dull pink, always reminded me of the one that can be seen in Napoleon's dressing case in the Carnavalet, or wherever it is.

One evening when he had to change shirts to attend a dinner in town, Degas ushered me into his room. He took off every stitch of clothing and dressed in front of me without the slightest embarrassment.

Whenever I went into the studio, Degas would be milling about, dressed like a pauper in old slippers and loose-fitting trousers that were invariably unbuttoned. A door open wide clearly revealed, farther back, the most private of places.

Here, I mused, is a man who once was elegant, whose manners, when he chose, could be of the most unforced distinction, who used to spend his evenings in the wings of the Opéra, a frequent visitor in the paddock at Longchamp, a supremely sensitive observer of the human form, a supremely cruel authority on female contours and poses, a discerning connoisseur of the finest horses, the most intelligent, most reflective, most demanding, most ruthless draftsman on earth...not to mention being a wit, the guest whose comments, in their sovereign breach of fairness, in their selective truth, could prove lethal....

Eugène Manet (Berthe Morisot's husband), 1874.

One day, I was walking with Degas through the Grande Galerie of the Louvre. We stopped in front of a large painting by Rousseau, a magnificent depiction of a lane of huge oak trees.

After admiring it for a while, I noticed how conscientiously and how patiently the artist, without detracting in the least from the overall effect of the clumped foliage, had so fully elaborated the minutest detail, or created so convincing an illusion that he had, that it suggested endless drudgery.

"It is superb," I said, "but how tedious, painting all those leaves. What a dreadful bore that must have been."

"Be still," Degas said. "Had it not been tedious, there would have been no enjoyment in it."

Berthe Morisot and Her Recollections of Degas

Here are some observations Degas made at Berthe Morisot's table and which she recorded in a notebook.

Degas once stated that the study of nature was meaningless, painting being an art of convention, and that it was better by far to learn drawing from Holbein; that Edouard [Manet] himself, though he prided himself on slavishly copying nature, was the most mannered painter on earth, never making a brushstroke without thinking of the masters, never putting, say, fingernails on hands because Frans Hals didn't. (Here it seems to me Degas made a mistake. Hals did so draw fingernails, even Descartes'.)

(At dinner, with Mallarmé): "Art is falsehood!" [Degas] explained that a person can be an artist only when the time is right and through an effort of

will. Objects have the same outward appearance to everyone....

Degas once said: "Orange imparts color, green neutralizes, violet shades."

Degas told [Georges] Charpentier he ought to publish a New Year's edition of *Au Bonheur des Dames* [Zola's novel about shopgirls] with samples of fabric and trimmings on facing pages. But Charpentier did not catch on. He (Degas) professed the deepest admiration for the very *human* quality of young shopgirls. According to him, Zola wrote *L'Oeuvre* solely to prove the tremendous superiority of writers over artists; in real life, the wretched painter dies from his attempts at the *nude*.

Finding himself one day at the far end of a table where Goncourt, Zola, and Daudet were talking shop, Degas remained silent. "Well, now!" Daudet said to him. "You *do* despise us, don't you?" "I despise you as a painter," he replied.

He recalled Edouard Manet's remark as he introduced him to P[aul] Alexis: "He does cafés from nature!"

Paul Valéry
Degas Dance Drawing
1934

Ambroise Vollard Remembers

Only fellow dealers Paul Durand-Ruel and Hector Brame did more than Ambroise Vollard (1865–1939) to further the Impressionist cause. He started out in the art business just as it was losing two of its giants, Theo van Gogh and Père Tanguy, and handled the work not only of Degas, Renoir, and Cézanne, but Matisse and Picasso as well. In doing so, he acted as a bridge between the already "historic" movement of Impressionism and the emerging

generation of avant-garde artists. Late in life Vollard wrote several books about painters he had known and an autobiography, Recollections of a Picture Dealer.

I called on Degas to invite him for dinner.

"Certainly, Vollard," he said. "Only, listen carefully: will you have a special dish without butter prepared for me? No flowers on the table, and dinner must be at seven-thirty sharp. I know you won't have your cat around, but no one will be allowed to bring a dog, will they? And if there are any women present I trust they shan't come smelling of perfume. How awful all those odors are when there are things that smell so good, like toast. Or even the delicate aroma of s—t! Oh, yes,…and very few lights. My eyes, my poor eyes!"

Degas used to play up the fact that he "couldn't see" to obviate the necessity of recognizing people. Only, one day he ran into someone he had known for thirty years and asked him his name—"These eyes of mine, you know!"—then forgot he "couldn't see" and pulled out his watch.…

Degas' life was as well-ordered as a sheet of music: the studio from morning till night. When things were going well he would hum something, usually an old tune. From the landing you could hear snatches of songs, such as

I'd sooner keep a hundred sheep
Without a dog or shepherd's crook
Than keep a lass whose heart, alas,
Is nothing but an open book.

Degas sometimes poked gentle fun at his models. "You are a rare specimen,"

Ambroise Vollard.

he might say to one of them. "You have buttocks shaped like a pear, like the Mona Lisa," and the girl, beaming with pride, would walk about showing off her buttocks.

But if Degas was known to indulge in familiar talk around his studio, he did not countenance even the slightest indiscretion on the part of his models.

One day a model he was particularly fond of cried out in the middle of a session:

"Is that *my* nose, M. Degas? My nose never looked like *that*." Whereupon the model was promptly ejected from the room, and her clothes tossed out after her. She was left to dress on the landing.…

Degas abhorred science.

"No one will ever know the harm that chemistry has done to painting," he was always saying. "See how the

color has cracked on this canvas; what on earth could they have put into it?"

In this particular case, however, he realized that he had no one but himself to blame, for he had painted over a white-lead priming that was too fresh.

He was also a stickler when it came to the composition of the paper he used for his pastels; except that, because of the very way he worked (tracing over tracing), his pastels were usually done on tracing paper. Then Lésin would mount them onto sturdy Bristol board.

Then there was the matter of fixatives. He had no use for commercial fixatives, as he found that they left a sheen on the surface, and "ate into" the color besides. The fixative he used was prepared expressly for him by a friend of his, Chialiva, an Italian-born painter of sheep; and future generations owe him a debt of gratitude for the part he played in preserving Degas' work. It should be added that Chialiva took his secret with him to the grave. The fact that Degas "reworked" his pastels over and over again made it all the more imperative for him to have a good fixative: Since this process had to be repeated before each new state, it was essential that all the layers of color adhere thoroughly to one another....

Degas stopped taking the omnibus toward the end of his life. He went on long walks instead, which never seemed to tire him out. This was actually a telltale sign of bladder trouble, which preoccupied him more and more as time went on.

So much, in fact, that one day when a model came to work for him, instead of greeting her with the customary "Disrobe," the painter, holding his

bowl of cherry-stem tea, blurted out unwittingly:

"Do you have trouble peeing? I do, and so does my friend Z."

I ran into Degas one evening on the Boulevard des Italiens and, since he was going home for the night, suggested that I accompany him. He lived near Place Clichy at the time. Because of this urge he had to be constantly on his feet, he took me a roundabout way past the Bastille. As we walked along the sidewalk, Degas would stop in front of shop signs and the placards pasted on the plate glass of the display windows, then gaze at me quizzically. Then I would read them out loud: *Chaussures de Limoges; Ribby habille mieux; Poule au gibier.*

Degas sometimes stopped off in a café located downstairs from where he lived and watched men play billiards as he lingered over a cup of hot milk. If they were late in coming, he would walk up to the cashier: "What's become of your billiard players?"

One day I went to the café with him, and we found them at their usual stand.

"People call me the painter of dancers. They fail to see that I regarded ballet dancers as a pretext for painting pretty fabric and rendering movement."

It was another matter altogether when it came to movement that was useless to him as a painter. Once when he was in someone's drawing room, a lady sitting across from him had her legs crossed and kept swinging her foot incessantly. Degas looked uncomfortable.

Suddenly, with the agility of a young man, he leaped forward as if about to throw himself at the lady's feet. She smiled at first, but immediately jumped up with a shriek: Her "ardent admirer"

had grasped the fidgety foot:

"Keep still! You're turning my stomach!"

Another time, while dining at a friend's, his host reached forward to ring the table bell. Degas grabbed his arm.

"What do you intend to do?"

"Why, ring for the maid."

"Why ring?"

A moment later:

"Where ever can the maid be?"

"She is waiting for me to ring."

"*I* do not ring for Zoé."

<div align="right">Ambroise Vollard
Degas
1924</div>

Daniel Halévy's Friend Degas

Though little known today, historian and essayist Daniel Halévy (1872–1962), the son of Ludovic Halévy, was undoubtedly one of the most original figures of the 20th century. His friendship with Degas, whom his father had known since childhood, weathered even the estrangement precipitated by the Dreyfus affair. Although his notebooks have yet to be published in their entirety, some of his recollections were released shortly before his death as Degas Parle, *1960.*

26 December 1890

Dinner. After dinner Elie and I cornered Degas. He was charming.

"I wish," he began, "there were in Paris a nice, quiet place with serious music where a person could smoke and drink. In England there's a café, a public house, where they sing Handel in chorus."

"Why, that's preposterous," I replied. "You won't find in Paris two hundred people who smoke, drink, and appreciate good music."

"That's what you think: There are even Buddhists in Paris. If tomorrow you were to open your own little shrine, you'd see people coming by the streetcarful with their wives and children."

"For that matter," I went on, "I think it is wrong to want to hear Gluck or dramatic music performed as

oratorios, without any staging or scenery. You yourself said so this past summer when, after hearing the flute air from *Orpheus* performed in a beautiful natural setting, you

Degas in Paris, c. 1914. From the film *Ceux de Chez Nous.*

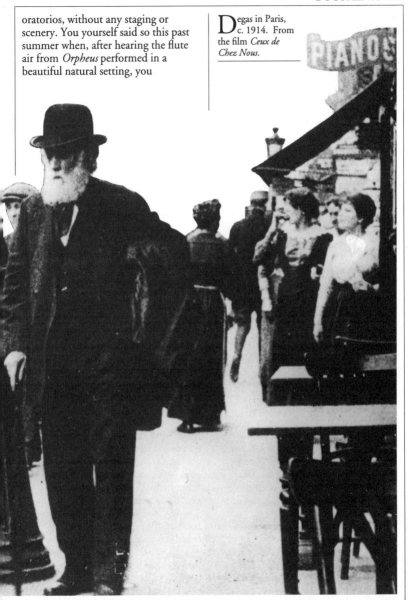

D aniel Halévy, c. 1895. Photograph
 by Degas.

acknowledged that it was as if the
music had been left behind in the
theater."

"You missed the point," he said.
"What I meant was that music is one
thing and nature another, that art
requires suitable surroundings."

I talked with him about various
paintings of his I had seen at Goupil's
on Boulevard Montmartre. He enjoyed
reminiscing, laughed as he described
the fashions of the day, made fun of
little Second Empire bonnets and little
1873 jackets.

The conversation came around to the
subject of reading.

"I cannot read any more," he said.
"My maid reads the newspaper to me."

It was Zola, I think, that started us
talking about books.

"I have read *L'Assommoir* and *Nana*."

(Me): "You've read *L'Oeuvre*, haven't
you?"

"No."

"But it was back then, wasn't it, that
you knew Zola quite well and had talks
with him?"

"No" (his face lit up). "That was
earlier, with Manet and Moore at the
[Café de la] Nouvelle-Athènes. We had
endless discussions."

He said nothing for a while, then
continued.

"This concept of art Zola has,
cramming all there is to know about a
subject into a single tome, then moving
on to the next subject, strikes me as
puerile."

(Elie) "That is simply the way Zola's
mind works when it comes to art."

Another brief silence, then:

"Perhaps you have a point. We
painters do not have a synthetic turn of
mind. No, I take that back: We have it
in a sense that no one else does. We can
say more in a single brushstroke than a
writer can in an entire volume. That is
why I shun those speechifying critics,
and all those painters who let
themselves be taken in by their
phrasemongering. Among ourselves, we
exchange a word or two of [artist's]
slang…and that's enough. But we have
no general ideas."

Degas then mentioned that he had
read Proudhon's book on the arts. I had
heard him talk once before about
Proudhon, not unadmiringly.

(Me) "You seem to be know quite a
bit about Proudhon. I believe I've
heard you speak of him before."

"That's right," he said. "I've read *La
Justice, L'Art, Les Confessions:* wonderful
books!"

"He must have been even better at

conversing than he was at writing,"
I said.

"Indeed he was. To do a book he would take a subject he had learned about while chatting with people and then write three hundred pages. It seems he would pick their brains, saying little himself, until an idea turned up in the course of conversation. Then he would leave."

"Have you read his letters? That is where you see him best."

"A little."

"Did you ever actually see him?"

"Once, on the Quai Malaquais. He was wearing a long overcoat with a pleat in the back."

"And did his head look a little like a billy goat's?" asked Elie.

"No. Like Socrates. And he would always peer at you from behind spectacles. I remember hearing Madier de Montjau tell how in 1848 when Proudhon was provoked by Piat he beat him black and blue, and their friends decided that they ought to fight a duel. The duel took place, there were some scratches, and that evening Madier saw Proudhon, deeply humiliated and wounded in his dignity as a philosopher to have come so close to killing or being killed for so trifling a matter. He was a surprisingly strong man. The odd thing is that he never attacked Veuillot and that Veuillot never attacked him. They were afraid to.

Degas also talked about the passages in *La Justice* on Proudhon's childhood and on literature. He also mentioned a note in *Le Principe de l'Art* on pretty women.

29 November 1894

Degas: his eyes hurt terribly. Holding his own, pretending awfully hard to be happy. Now his cheerfulness comes by fits and starts, with intermittent anger.

"I've never felt younger than I do today," he keeps on saying. I sat next to him at the Gauguin sale (last month): what intensity! He kept upping the bids and got carried away by prices that frightened even him. What's more, he could not see the pictures he was buying. "What is it?" he would ask me; then he would remember. He bought a copy of the *Olympia* he had never seen. He would lean over to people sitting near him and ask, "Is it beautiful?"

29 December 1895

Last night we had a delightful dinner: Uncle Jules, Henriette, Aunt Niaudet and her two daughters, and Degas. Uncle Jules says little, my aunt nothing at all. That left, in addition to us, the three young women and Degas. The

Emile Zola.

three girls are charming: Henriette—so delicate, so pale, so slight, looking as though she'd flitted out of an English novel—and her cousins.…

Degas is, of course, a very old friend of Uncle Jules, but sees little of him, and only at our place, as they live so far apart. We were sure Degas would be glad to see Henriette; he is so sensitive. About two years ago, he was in Touraine and had lunch with the Taschereau-Niaudets in Montguerre. He told Mama about this luncheon. "I must have struck them as very odd. Louise, you would not believe how uncomfortable it made me, finding myself there among those grown-up children. I couldn't think of a single thing to say to them." Mama often considered having all of them over at the same time but was afraid of the effect Degas' rather blunt remarks might have on these very old-fashioned girls. But now that they were all in their twenties, Mama decided to ask them over. I sat between Henriette on my right and Mathilde on my left; Degas sat on Mathilde's left.

It would be tiresome to repeat what was said. Degas was in good spirits, obviously happy. He was most attentive to his neighbor and conversed with her graciously. After dinner, he got up and went to his studio with Uncle Jules to fetch his camera. A fortnight ago, we had him, Uncle Jules, and the Blanches for dinner. Then, as now, he felt he had to fetch his camera after dinner, and I went with him. He talked to me all the while. In his studio I noticed various little pictures he had done in his youth of his sister and his brothers; the ones he'd been looking for. After we got back, I don't know how, but he happened to say to Uncle Jules, "I'd

have hated to go alone, but Daniel kept me company." I was struck by this sad remark; it must have struck my uncle, too, because yesterday, as Degas was leaving by himself, he got up from the table and went with him.

They returned together; the *pleasure* part of the evening was now over. Degas raised his voice, became dictatorial, ordered that a lamp be brought into the little drawing room and that anyone not posing should leave. The *business* part of the evening got under way. We had to defer to Degas' dread will, his artist's ferocity. These days all his friends speak of him with terror. If you ask him over for the evening, you know what you're letting yourself in for: two hours of military obedience.

Despite the directive banishing all nonposers, I stole into the drawing

Élie Halévy and Mme. Ludovic Halévy in Degas'

room and silently watched Degas in the dark. He had seated Uncle Jules, Mathilde, and Henriette on the little sofa in front of the piano. He walked in front of them, scurrying from one corner of the drawing room to the other with an expression of supreme happiness. He moved lamps, changed the reflectors, tried to light their legs by putting a lamp on the floor—those famous legs of Uncle Jules, the slenderest, most supple legs in Paris, which Degas always talks about so rapturously.

"Taschereau! Hold on to that leg with your right arm and pull it in. There, that's it. Now look at that youngster beside you. More affectionately. More!...Come now, you can smile so nicely when you've a mind to. And you, Mademoiselle Henriette, tilt your head. More! Even more! Really

living room, c. 1896–7. Photograph by Degas.

tilt it! Rest it on your neighbor's shoulder." And when she did not follow his instructions satisfactorily, he grabbed her by the nape of the neck and positioned it as he wished. Then he took hold of Mathilde's face and turned it toward her uncle. Then he stepped back and exclaimed happily, "That's that!"

They held the pose for two minutes—and so it went. We shall see the photographs tonight or tomorrow evening, I think. He unveils them at our place, always looking happy. To tell the truth, at such times he is happy.

At half past eleven everyone left— Degas, surrounded by three laughing girls, shouldering his camera, as proud as a child carrying a rifle.

23 February 1897
Degas, last night. Went over to read to him the second part of [Antonin] Proust's recollections of Manet, published in the *Revue Blanche*. I found him alone in his little dressing room. That is where he eats.

"Oh, it's you!"

"I've brought you the Manet."

"Read it."

I opened the magazine. He saw a drawing, pulled out his magnifying glass and peered at it. It was a café-concert singer.

"That Manet! As soon as I did dancers, he did dancers. He was forever imitating. Read."

I read. I had been reading for some time when I came to a brief sentence about *Le Déjeuner sur l'Herbe* and plein air. Degas stopped me.

"That's not true. He's got it all mixed up. Manet wasn't thinking about plein air when he did *Le Déjeuner sur l'Herbe*. He didn't think about it until

he saw Monet's first paintings. All he could ever do was imitate. Proust's got it all mixed up. Literary people! Why can't they mind their own business? *Such matters are best left to no one but us.* Read on."

I continued reading, and he interrupted me now and again with minor technical corrections. I finished. "That's all," I said.

Degas kept quiet for a moment. He leaned back in his chair and gave a sidelong glance, then in his "nice" voice—the intimate, sad voice I love,

not the contentious one that is now becoming somewhat routine—he said:

"Literary people! They can't leave you alone. To be handed over to literary people…a fate worse than death!"

1908

Death of my father. Degas paid his respects.

I was informed Degas was here. I could tell he had death on his mind.

Degas stood in our dining room in front of the big window. "It is here," he

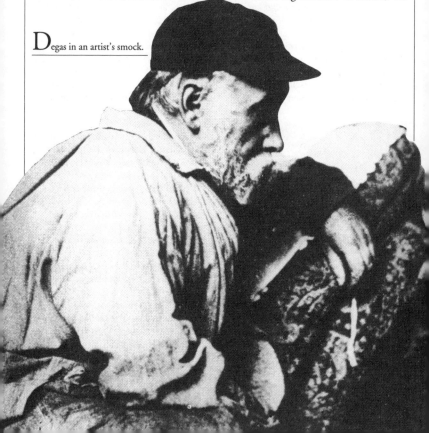

Degas in an artist's smock.

said to me, "that I broke the news of Henri's death to your grandparents."

Then it dawned on me: the death in 1871 of Henri Regnault, slain at the battle of Buzenval during the siege of Paris, a friend of both our families.

"I want to see your father," Degas said.

My father was upstairs. We went up to the room where they had laid him out. It was dark. In a booming, dictatorial voice Degas cried out, "Light, all the light you've got!"

I called Francine, she opened the curtains wide.

Then Degas leaned over my father's body and looked very closely at his face. Finally he straightened up and turned towards me:

"This is the Halévy we've always known, all right, plus that grandeur that death imparts. This must be preserved."

He left. *This must be preserved.* Those words struck me. I thought about Paul Renouard, an artist Degas had encouraged when he was just starting out and whom my father had met through him. Paul Renouard lived on Place Dauphine; I found him in. He came over, worked for two hours, and did a fine drawing. But that is all it was. It lacked "that grandeur that death imparts." Only Degas could have captured that.

25 January 1913

Degas still so beautiful. That semi-absence of the mind that presages death. But the moment someone speaks to him, that presence, that energy, that clearness of eye and voice.

"Bravo Degas!" Mme. Ganderax said to him in front of his picture. "*That* is the Degas people love, not the Degas of the [Dreyfus] affair.

"Madame, it is the whole Degas I want people to love."

Someone asked him, "All the same, you're not unhappy with this picture, are you?"

"I'm fairly certain that whoever painted it is no moron; but I'm quite certain that whoever paid so much for it is a bloody fool."

Someone congratulated him on the price. He shrugged his shoulders.

"I am a racehorse," he said. "I run the big races, but I am satisfied with my ration of oats."

Daniel Halévy
Degas Parle
1960

Georges Jeanniot: Degas the Racehorse

A painter best known for his engravings and illustrations, Georges Jeanniot (1848–1934) met Degas in 1881 at the home of his old friend Ludovic Lepic. In

Dancer from the corps de ballet, c. 1896. Photograph by Degas.

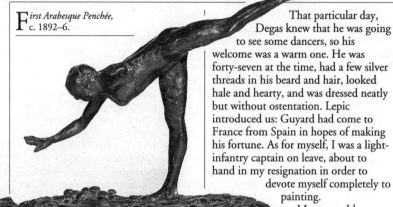

First Arabesque Penchée, c. 1892–6.

1890 Degas spent some time with Jeanniot at Diénay (in Burgundy), where he produced his first landscape monotypes. Jeanniot, whom Pissarro considered a "kind but artistically uninteresting" artist, later published recollections of Manet, Forain, and Degas that are anything but uninteresting.

During that already distant period, Degas was unknown to the general public; the great painter commanded the admiration and respect of no one save a few enlightened collectors and a few artists trying to find their way in life outside the art establishment. I had never seen him before, and my initial impression was that I was in the presence of an exceptionally distinguished man, a man of subtlety, effortless composure, and irony.

His was a most intelligent head, with a very high brow and a pleasing oval shape. Now and then, his usually serious eyes would look amused, especially whenever he came out with one of those *mots* of his, so carefully crafted and so highly effective, too.

That particular day, Degas knew that he was going to see some dancers, so his welcome was a warm one. He was forty-seven at the time, had a few silver threads in his beard and hair, looked hale and hearty, and was dressed neatly but without ostentation. Lepic introduced us: Guyard had come to France from Spain in hopes of making his fortune. As for myself, I was a light-infantry captain on leave, about to hand in my resignation in order to devote myself completely to painting.

Moreover, I knew precious little, never having had the time to work uninterruptedly. Degas looked at our drawings. He showed us how a dancer's foot ought to be observed. In language that hinted at long years of study, he propounded upon the distinctive form of satin ballet shoes held in place by silk cords twined about the ankles. Suddenly he grabbed a charcoal pencil and in a few heavy, black lines constructed the foot of the girl who was posing; then he smudged out some shadows and half-tints with his fingertip. The foot was alive, sculptured, its contours wrought with an unerring spontaneity that freed it from the commonplace. Degas held us spellbound; he had a way of putting things, of phrasing his sentences, of touching upon a subject with a pithy remark, that only the masters possess.

His opinions were interspersed with anecdotes about various famous artists who had bowed to the rewards of officialdom. He spun them out with charming humor and lightness of touch.

Some time later, I had a bit of a shock when I went to the Rue Fontaine and rang his bell.

He answered the door wearing a felt hat and a long housepainter's smock. He was working on a picture of racehorses.

"They are jockeys in the country," he said....

I watched Degas work. He compounded colors, wiped with a rag, dipped the end of his brush in the mixing saucer, hesitated. Finally, he made up his mind and with a quick, light movement spread a yellow color across the monochrome painting. Then he turned around and said:

"That is what's known as a glaze."

In everyday life, Degas' high-strung temperament would flare up suddenly, impulsively. I had him for dinner one evening. He had taken off his coat and was getting ready to enter the drawing room when a magnificent pedigree bitch burst in and frisked over to bid him welcome. He gave her a violent kick; the bitch dodged the blow by leaping backward. She stopped short and eyed her enemy in a calm, serious way. She kept her distance the whole time Degas was there.

These outbursts of temper aside, he possessed a dignity that placed him in the higher sphere of the elite, as the following anecdote will attest.

It was at the sale of his friend Henri Rouart. It was being held in the main hall of the townhouse in which Manzi and Joyant had set up their business in paintings and objets d'art. Degas kept to himself in another room. Suddenly a journalist came running in.

"M. Degas! Do you know how much your picture of two dancers at the bar, with a watering can, just sold for?"

"No, I don't."

"Four hundred seventy-five thousand francs!"

"That *is* a nice price," said Degas.

"Why, don't you think it's outrageous that this picture will never bring you more than the five hundred francs you were paid for it?"

"Monsieur," Degas replied, "I am like the racehorse that wins the Grand Prize: I am satisfied with my ration of oats."

There dwelled within him an innate contempt for the meanness that money and honors bring out in people.

At the World's Fairs of both 1889 and 1900, I know that someone acting on behalf of the government offered him the use of a room in which to exhibit his work. He turned it down. That pride is as uncommon as it is noble. Of course, no honors were conferred upon Degas.

Deep down he realized how good his work really was, and in this respect his conversation reminded me of the nice comeback an 18th-century philosophe once had for someone who asked, "You consider yourself very talented, don't you?" "In my own estimation, no; compared to others, yes."

Degas went a bit deaf; so did I, much more so in fact. He found writing tiresome; our relationship suffered for it, but I thought about him a great deal.

During the war, in 1917, Degas, by then decrepit, told Mme. Jeanniot that he wished to come to our place for dinner. She promised to call for him in person.

We were glad to lavish attention and affection on him, and it seemed to touch him.

Suddenly, around ten o'clock, he got up to leave and insisted that no one see him home. We wouldn't hear of it; he lost his temper.

The streets were dark. We anxiously went out behind him and trailed him at a distance. He was wearing his hooded cloak and an old bowler hat, and he kept close to the houses, which he tapped at now and then with the tip of his cane. He moved along slowly. Finally he hailed a carriage on Avenue Victor Hugo.

Mme. Jeanniot called on him some time later and told me how her visit had gone.

"A short, disheveled maidservant opened the door and called out, 'Mme. Zoé!' Faithful old Zoé shuffled in wearing slippers, lighting her way with an oil lamp that gave off an unpleasant smell. 'Monsieur is lying down,' she said to me, 'but you may see him.' I crossed the shuttered parlor that housed in darkness the nude or clothed figures he had modeled.

Degas was in his room, lying flat on his back; his head was raised and covered with a cotton nightcap. His long, white beard and hair stood away from his calm face. He offered his hand, smiled, told me how happy he was to see me, and asked me to reminisce about the past, about youth.

"I spoke in a very loud voice and made a point of enunciating, but he did not hear me and took me to task for 'mumbling.'

"He wasn't ill, only old, and since it wasn't nice out and he couldn't leave the house, he preferred his bed to his armchair.

"Seeing him that way reminded me of the time he had a cold when he

lived on Rue Ballu. He had wrapped a strip of cotton wool around his head. Bartholomé tried to explain to him that this treatment was ineffective, 'Still,' he sniffed, 'I do not intend to die for lack of care.' That hurt Zoé very deeply.

"Today he was having one of his better days. We talked about the famous trip to Diénay in a tilbury pulled by a white horse. He tried to remember, but sometimes he needed a little prodding about specific details.

"On his bed there was a black coverlet embroidered with red and white flowers. I looked at it.

"'My sister from America gave me this quite a long time ago!' he said.

"'A Tunisian stitch?' I inquired of Zoé. Degas had trouble hearing.

"'What's that you say? Tunisian? Ridiculous!…What?…Speak up!…Heavens, but you're mumbling! Come here, close to me, take off your hat.'

"I brought my head right up to his eyes. 'So, now you feel it's time you did my portrait, M. Degas!' I said. 'I'm not pretty any more.'

"He smiled and said nothing. He asked me over for lunch next Wednesday, as his brother is coming that day."

A week later, my wife gave me another report when she got back from this lunch.

"I arrived at twelve o'clock sharp. His niece was busy dressing him because he was tired and had gotten up late. Zoé drew up alongside me in the dining room and told me that this niece had recently moved in to be near her invalid uncle. Degas' brother bears some resemblance to him and, like the artist, makes

frequent use of the familiar 'What!' and 'Speak up!'

"Degas walked into the dining room; he was propped up by his niece.

"His very long, silky hair hung down over his ears and neck; a black cap with a shade shielded his eyes from the daylight. The rest of his face was clearly visible and I noticed rather a pronounced hollow under his right cheekbone. He stood leaning heavily to one side, one shoulder considerably lower than the other. He had trouble walking. He offered me a friendly hand and shook mine for a long time. He embraced me.

"We sat down at the table. Zoé had fixed him a thick slice of meat, which he ate heartily, and some peas. He did not speak.

"From time to time, he would pay attention to what was being said, but since he had difficulty hearing he would lose his temper and shout:

"'Heavens, but you're mumbling!'

"I leaned forward and tried to distract him…. But today he couldn't remember anything anymore, or wouldn't.

"He is already a different man.

"As I left, deeply moved, Zoé said to me tearfully, 'Oh, Madame! To see what's become of the gentleman Monsieur used to be, it's very distressing, I assure you!'"

Georges Jeanniot
"Souvenirs sur Degas"
La Revue Universelle
15 October and
1 November 1933

Degas looking at the statue *Fillette Pleurante* by Albert Bartholomé.

Degas the Sculptor

With the exception of The Little Fourteen-Year-Old Dancer, *Degas' sculptures remained in his studio and were not discovered and inventoried until after his death in 1917. Most were made of wax and by then had so deteriorated that only seventy-three of the 150 pieces found in his studio could be cast in bronze, and only then after restoration by the sculptor Albert Bartholomé.*

Journalist François Thiebault-Sisson's article about the confidences Degas shared with him is a key source of information about the chronology of Degas' activity as a sculptor.

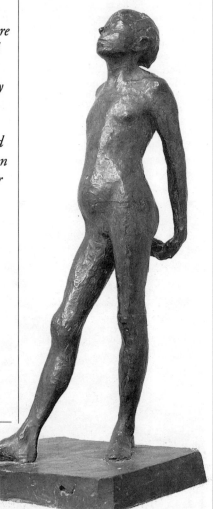

N ude study for *The Little Fourteen-Year-Old Dancer,* 1878–80.

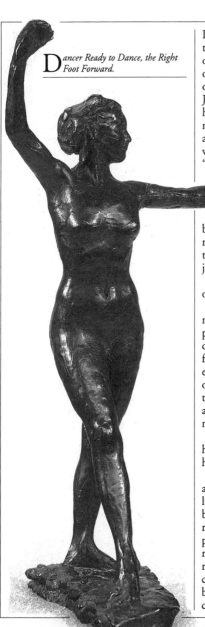

Dancer Ready to Dance, the Right Foot Forward.

It was in 1897, in Clermont-Ferrand, toward the end of July or the beginning of August. The clocks had just struck one. I was on my way back from Royat on foot. As I was cutting across Place Jaude at a diagonal to lunch at the hotel, I bumped into a gray-bearded man bundled up in a bulky macfarlane and so deeply absorbed in thought that when I apologized he gave a start. "What are you doing here, M. Degas?" I exclaimed.

"I say, is that you? I'm dying of boredom, that's what I'm doing. I've been in [the hospital] the past week for my throat. This morning I had an urge to come here for diversion, and I am just as bored here as I was back there."

"Let me try and take your mind off things."

"You won't be able to. I am a dead man, or might as well be, because for a painter the thought of going blind is death." He proceeded to tell me that for the last twenty years or so his eyesight had been deteriorating. The oculists he consulted had been unable to determine the cause. The remedies and eyeglasses they prescribed had done nothing to alleviate the disorder.

I interrupted him. "You can't have had lunch yet. How would you like to have lunch with me?"

He let himself be prevailed upon, and off we went, arm in arm, to have lunch. The proprietor of the hotel had been forewarned and lived up to his reputation; the fare was delicious. The profit was all mine, though, for with a mischievous twinkle in his eye, Degas raked some of his colleagues over the coals, leveling at them criticism so beastly, yet so witty and accurate, that I cried from laughing. Little by little, my

laughter became infectious and his scowling face brightened up. By the time we got up from the table he was a different man. Life didn't look so grim to him now. "You are the best of doctors, even though there is no such thing as a good doctor," he muttered with an outright smile. "So I refuse to part company with you. It's time I headed back to [the hospital]. Pack your things. You're coming with me."

The offer was too tempting to turn down. I never left his side for two solid days....

Even though Degas was not a fanatic when it came to draftsmanship, unlike his revered M. Ingres, this natural inclination alone might account for the distance at which he always held Delacroix. "In art," he said to me, "one is never entitled to deviate from the truth. But this truth," he added, "may be rendered only if one does not deliberately seek out ugliness to the point of being blind to all else. I have the strongest aversion for those platitudinous realists we see today basing their interpretations of life solely on the seamy side of human nature. The true realist holds nothing back, but puts everything in its proper place; he classifies the elements that go into his composition according to their degree of interest, making unavoidable choices in the process. If those choices are judicious, it is style. Take Chardin, for example: he depicted the most pedestrian of subjects in an admirably conscientious way and still managed to lend them elegance, grace, and distinction."

It was during these conversations that Degas mentioned in passing his attempts at modeling, which his failing eyesight had led him to substitute for painting as a means of expression. When I asked him whether his apprenticeship in this new craft had given him any trouble, he exclaimed:

"Why, I've been familiar with this craft for a long time! I have been practicing it for more than thirty years, not on a steady basis, to be sure, but from time to time, whenever I've felt like it, or needed to."

"Why ever should you need to?"

"Have you read Dickens, Monsieur?"

"I certainly have."

"Have you read any biographies of him?"

"Not a one."

"You don't mean it! Well, then, it is I who must inform you that whenever he reached a critical juncture in one of those passages at which he excelled, the ones with multiple protagonists, and whenever he began to get lost in the tangled web of his characters and did not know what their fate should be, he would extricate himself for better or for worse by constructing figures and giving each of them the name of a character. When he had them on the table in front of him, he could see them in his mind's eye taking on personalities that might or must suit them; he had them talk to one another.... Everything would immediately fall into place, and the novelist could resume his task more clear-wittedly and bring it unflinchingly to a successful conclusion. I adopted his method instinctively. You may be aware of the fact that about 1866 I perpetrated a *Scène de Steeplechase*, the first, and for a long time the only, picture of mine inspired by a racecourse. Now, although at the time I was reasonably familiar with 'the noblest conquest ever made by man,' although I had occasion

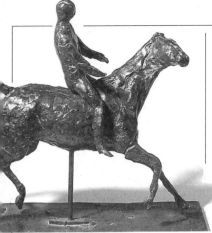

Jockey on a Galloping Horse, Its Head Turned to the Right.

to mount a horse fairly often and did not have too much trouble telling a thoroughbred from a half-breed, and although I even had a pretty good grasp

Eadweard Muybridge's stop-action photographs of a galloping horse, 1878.

of the animal's anatomy and myology from having studied one of those plaster anatomical models you'll find in any caster's shop, I knew absolutely nothing about the mechanism of a horse's movements. I knew infinitely less about the subject than a non-commissioned officer who through long, diligent practice can visualize a horse's reflexes and reactions when talking about an imaginary animal.

"Maret had not yet invented the apparatus that makes it possible to separate motion that is imperceptible to the human eye—a bird in flight, a galloping or trotting horse—into a series of stop-action images. In order to do those sincere studies of horses he found useful for his military paintings, Meissonier was reduced to parking his carriage for hours at a time along the sidewalk on the Champs-Elysées to observe riders and teams of handsome, frisky steeds as they passed by. Consequently, this bad painter was one of the

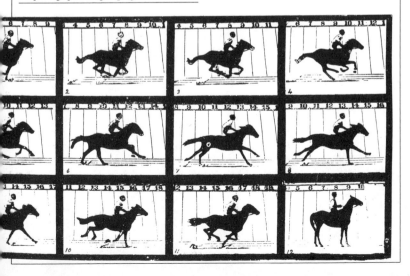

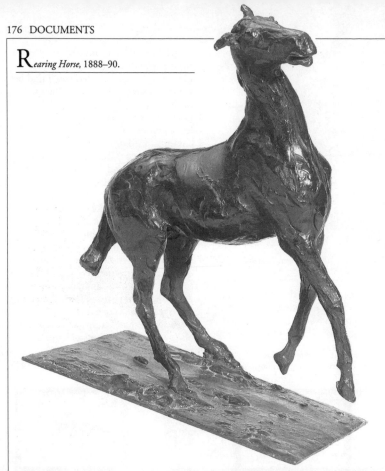

Rearing Horse, 1888–90.

best-informed about horses I ever met!

"I wanted to do at least as well as Meissonier, but I did not confine myself to sketches. Before long it became clear to me that whatever they had to teach me would lead nowhere unless I made use of them in modeling experiments. The older I got, the more I realized that in order to depict animals with that flawless accuracy which makes them come alive, I needed to move into three dimensions, not only because the act of modeling demands prolonged observation and sustained attention on the part of the artist, but because it countenances no approximations. The most beautiful, most impeccably crafted drawing always falls short of the precise truth, the absolute truth, and for that very reason leaves the way open for falsehood. You are familiar with the much-acclaimed drawing, and deservedly so, in which Fromentin captures the stride

of a galloping Arabian stallion. Compare it with a real one, and you will be far less impressed by what it conveys than by all that it lacks. The natural disposition and true character of the animal are not present in this enthusiastic improvisation by a very clever man.

"The same holds for representations of the human form, especially of the human form in motion. Draw the figure of a dancer: with a little skill you might be able to create an illusion for a moment. But however painstaking your interpretation may be, you will end up with nothing more than a flimsy silhouette with no feeling of mass or volume, one that is less than wholly accurate. The only way to get at the truth is through modeling, because it has a coercive effect on the artist: he must see to it that nothing essential is overlooked. That is why, now that my bad eyes have made it impossible for me to paint, now that I cannot work with anything but pencil and pastel, I feel more than ever the need to convey my impressions of form through sculpture. I examine my model's nose, note its various aspects in a series of sketches, and pull it all together in a tiny but solidly structured piece that does not lie."

"Actually, you are as much a sculptor as a painter, perhaps more so."

"Not on your life! I've made wax figures of animals and people solely for my own gratification, not as a respite from painting and drawing, but to give my paintings and drawings greater expressiveness, intensity, and vitality. They are warm-up exercises; preliminary documents, nothing more. None of it is intended for sale. Can you see me contriving my studies of horses the way Frémiet does, with that superabundance of picturesque detail the middle class always finds so impressive? Or contorting my studies of nudes into pseudo-elegant poses, like Carrier-Belleuse? You'll never catch me caressing the skin of a torso or reveling in throbbing flesh, which is all you critics ever talk about whenever you speak of the gentlemen of the Institut. For me, the essential thing is to express nature in all its aspects and motion with the utmost precision, to accentuate bone and muscle and the compact firmness of flesh. My work goes as far as irreproachable construction and no further. As for shuddering flesh—a mere trifle! My sculpture will never convey that impression of completeness that is the *ne plus ultra* of statue-makers; and, after all, since nobody will ever see these models, it will never occur to anybody to speak of them, not even you. Between now and the day I die, all of it will disintegrate of its own accord, and as far as my reputation is concerned, that is probably just as well."

François Thiebault-Sisson
Le Temps, 23 May 1921

H*orse at a Trough*, c. 1867–8.

Degas and Brothels

Interest in Degas' monotypes was late in coming. Recently catalogued by Françoise Cachin and Eugenia Parry Janis, who were largely responsible for their rediscovery, they are now considered among his most original works of art. After Degas' death, his straitlaced family was suspected of having destroyed a number of the brothel scenes that Picasso admired so much.

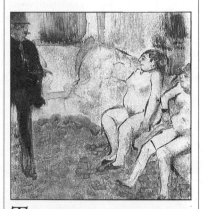

The Client, 1879.

Studying the monotypes puts one in a privileged position to understand Degas' work, giving access to his most personal and private concerns, his relations with women and with femininity. The very least that can be said is that a fascination with women, a mixture of love and disgust, is the obsessional theme that runs right through his work. But why should the monotype be more indiscreet and more revealing than Degas' other forms of expression? Apparently it is a fact that Degas did confine his erotic portraiture to this branch of his art, and his prudish family destroyed the majority of the pieces that might be considered indecent at the time the inventories were drawn up after his death.

In its life and immediacy the process is closer to the lightning sketch than the print. Because it is printed on paper, and because an element of chance affects the values and contrasts, it is close to photography, where one is never quite sure how a shot will look until the second stage of the operation. This technique is in some way more devious, more voyeuristic, than when something is drawn directly from life, where the confrontation between the portrait (painting or pastel) and the model takes place at the same time as the picture being created. Degas' recording mechanism was his eye; it was not until he was back in the studio that he called on his powers of memory and imagination and noted down in lithographic ink the scene he had observed and which he had, in a sense, stolen without the protagonists' being in the least aware of it.

In a way the monotype is a print, a technique that doubly distances the

scene represented because, between the act of the hand that draws and the finished product, there intervenes the printing process and the inversion of the image. Yet at the same time the monotype is, both in theory and by definition, a one-off impression, it is unique and it therefore retains the distinctive character of a drawing, something that is traditionally kept in a was also the most ambiguous, namely his relations with the world of femininity. Whether it is coincidental or not, the monotypes do provide an opportunity to get just a little closer to a particular aspect of Degas' vision of the world. While it may not add a great deal to what one can imagine for oneself about the private life of a middle-class misanthrope and hardened

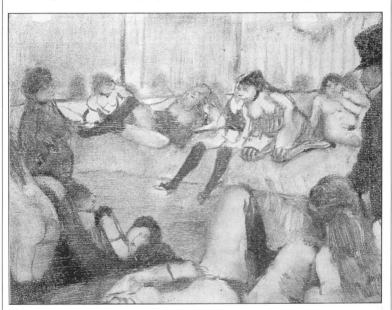

In a Brothel Salon, 1876–7.

portfolio and enjoyed by one person at a time. One feels it can hardly be by chance that Degas reserved this naturally ambiguous technique (an original produced by a process of reproduction, in which chance counts for as much as skill) for the very element of his own personality that bachelor, as regards his sensibility in general it is extraordinarily revealing....

There can be no doubt that the monotypes played as important a part as the studies of dancers in the development of Degas' concept of the nude. Within a single decade he moved from the academic Ingres-type nude of

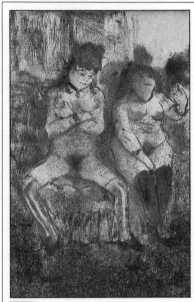

\mathbf{W}*aiting* (detail), 1876–7.

The Plight of the City of Orleans (1865) to the "clothes-wearing" bodies of the monotypes of brothels and of women washing themselves—from the nude to the undressed body. It is a great mistake to see cruelty or disdain in Degas' way of looking at his models, and people who thought this at the time were quite wrong. His attitude is far more ambiguous than that of some censorious cynic. When you look through the amazing series of monotypes of free-moving bodies, you might well be reminded of something Degas said about a woman being discussed over dinner with his friends the Halévys (the remark was recorded by the son): "'She's of the people!' said Degas with enthusiasm. And added:

"It's in the ordinary people that grace resides."

The nudes in Degas' monotypes are of two sorts, which may be described as "parodic" and "evocative." And curiously enough, Degas employed a different technique for each type. The parodic or caricatural nude is most often drawn on the plate as a positive image with a witty and vivacious line that recalls the Japanese drawings of wrestlers or prostitutes in, for example, the *Mangwa*. We know that Degas, as well as his friends Bracquemond and Tissot, became interested in Japanese art as early as the 1860s, and that all his life he kept in his room, alongside his drawings of nudes by Ingres, the Kiyonaga diptych of women bathing. The parodic nudes are animal in nature, more comic than obscene, and deposited in a setting rather as though they were puppets: in some of the brothel scenes the canopies, mirrors, hangings and the plush create an ensemble in which the body is merely an additional prop. The other category of nudes includes some of the most mysterious and evocative Degas ever created; they are all produced by the negative image method and have that ghostly quality inherent in a technique that makes white seem to emerge from blackness, lighted areas from the dark, and flesh from shadows. These nudes are for the most part of women performing their toilet, standing in front of a window, or in the bath, combing their hair, in silhouette against the light, or illuminated by the firelight from the hearth or by a lamp; they are conceived on a grander scale than the rest and have none of the improvised sketch-like character of the contemporary

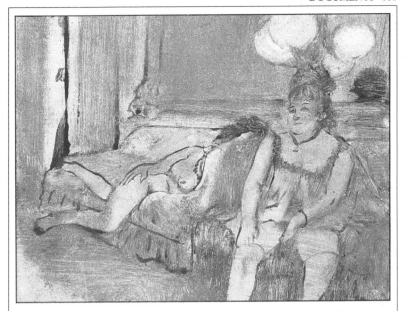

R*esting,* 1876–7.

nudes in the prostitute series.…

In the same style is a series of *intimiste* portraits of women preparing for bed or getting up in the morning, from a bed with curtains, wearing only their little nightcaps; these seem to have come straight out of 17th-century Holland. One thinks of similar scenes by Brouwer and particularly such Rembrandt engravings as *Woman with the Arrow.* Degas seems to have amused himself by depicting a respectable middle-class bedtime scene in such a way that, if you look at the monotypes in order, they can be read off like a film sequence. It is not only the subject matter and composition but even the mood they evoke that is reminiscent of the golden age of Dutch painting. And

it is interesting to note that Degas' allusions to the native art of Holland were instantly picked up by his contemporaries. After visiting the Salon of 1876, J.-K. Huysmans wrote of Degas: "I have never been attracted to any pictures but those of the Dutch school, which satisfied my need for reality and for domestic life, so for me it was in truth like being possessed. The modern life that I searched for in vain in the exhibitions of the time…was revealed to me at a stroke, quite perfect."

Huysmans, Goncourt, and the rest of the literary avant-garde of the 1870s and 1880s were, as it happened, peculiarly susceptible to Degas' brand of modern realism, and in this respect preferred him to the other painters of his generation. When Burty the critic wrote his review of the third

Impressionist exhibition, of 1877, at which a number of the retouched and pure monotypes were on show, what he found striking about Degas was that "he had chosen the more uncommon aspects of Parisian life.... In his attitude to them he shows himself to be a man endowed with feeling, wit, and a satirical eye, a speedy and most competent draughtsman.... The present-day Salons are too starchy to accept his delicate studies, whose literary equivalent is the pungent short story."

Most of Degas' monotypes were executed between 1875 and 1885, which coincides with the period when the naturalist novel was at the height of its popularity. One of these "more uncommon aspects" of Parisian life on which this branch of literature tended to concentrate was the theme of prostitution as a counterpoint to bourgeois life. Within a few years of each other, 1876–80, all of the following were published: *Marthe, Histoire d'une Fille* by J.-K. Huysmans; *La Fille Elisa* by Edmond de Goncourt; *La Maison Tellier* by Maupassant; and, of course, *Nana* by Zola.

Degas certainly seems to have been the first painter to tackle this major theme of naturalist literature—and, it must be said, in a more down-to-earth, less moralistic way than even Toulouse-Lautrec ten years after him. It is also the single theme that dominates the monotypes, accounting for about fifty in all.

The first thing that is so striking is the air of reality, of absolute immediacy, the feeling of a scene from life that has no idea it is being observed. Yet, by its very nature, the monotype has to be executed in a studio and

W*aiting*, 1876–7.

therefore belongs to the worlds of memory and imagination. Possibly Degas jotted down a few quick sketches, but if so no trace of them has been found, or not to our knowledge. Perhaps they were destroyed at a later date, together with the monotypes that were considered to be obscene....

Customers are a rare sight in this world of waiting; a little man in a bowler hat appears on the sidelines in a few scenes, hesitant and far from being won over. In the two monotypes that show him alone in a room with a prostitute, he is dressed and gazing at the woman, while she is either in the bath or combing her hair beside a basin. Because of the way he remains

outside the scene, because of his voyeurism and his interest specifically in the sight of a woman engaged in her most intimate toilet, one cannot help but identify this little gentleman with the artist himself. It is after all a fact that with the exception of the naturalist scenes, which are more anecdotic and tend to represent naked women draped over Napoleon III couches, and of a few reclining bodies, Degas' portrayal of nude women reveals what amounts to an obsession with the theme of women performing their toilet.

Just as the dancer was Degas' way of expressing movement, the woman at her toilet was a way of representing woman as she was. It is necessary to try and imagine what was meant in the 1870s by a "nude" or an "academy."

Degas' women are not nudes, they are women without their clothes, and those contemporaries who thought they were obscene were very well aware of that fact. These were the women they used to see in the streets, with whom they were intimate, and this certainly did not coincide with their mental image of the nude of antiquity; she, they had been taught, was made up of ideal elements encased in a silken skin. Because Degas showed women in what were considered to be animal attitudes, because he distorted the ideal academic proportions of the body by means of perspective, depicting what he saw and not what people ought to be shown, announcing like an innocent "the Queen has no clothes," he seemed to them a voyeur on whom all sympathy was wasted.

"M. Degas, who in the past in his admirable paintings of dancers conveyed quite remorselessly the decline of the hired girl, coarsened by her mechanical skipping and monotonous jumping, furnishes us now in these nude studies with a lingering cruelty and a patient hatred. It seems as though he is tormented by the baseness of the society he keeps and has determined to retaliate and fling in the face of his century the worst insult he can devise, overturning that cherished idol, woman, degrading her by showing her actually in the bath in the humiliating postures of her intimate toilet." This was the sort of interpretation put on Degas' vision—the speaker here being the author of naturalist novels, J.-K. Huysmans.

<div align="right">

Françoise Cachin,
Adhémar and Cachin,
*Degas: The Complete Etchings,
Lithographs and Monotypes,* 1986

</div>

Further Reading

Adhémar, Jean, and Françoise Cachin, *Degas: The Complete Etchings, Lithographs and Monotypes* (translated by Jane Brenton, foreword by John Rewald), Thames and Hudson, London, 1986

Adriani, Gotz, *Degas: Pastels, Oil Sketches and Drawings,* Thames and Hudson, London, 1985

Boggs, Jean Sutherland, *Portraits by Degas,* University of California Press, Berkeley, 1962

Boggs, Jean Sutherland, Douglas W. Druick, Henri Loyrette, Michael Pantazzi, and Gary Tinterow, *Degas* (exhibition catalogue), The Metropolitan Museum of Art, New York, and The National Gallery of Canada, Ottawa, 1988

Boggs, Jean Sutherland, and Anne Maheux, *Degas Pastels,* Thames and Hudson, London, 1992

Brame, Philippe, and Theodore Reff, *Degas et Son Oeuvre: A Supplement,* Garland Press, New York, 1984

Browse, Lillian, *Degas Dancers,* Faber and Faber, London, 1949

Courthion, Pierre, *Impressionism,* Harry N. Abrams, New York, 1977

Dunlop, Ian, *Degas,* Harper, New York, 1979

Gordon, Robert, and Andrew Forge, *Degas,* Harry N. Abrams, New York, 1988

Guérin, Marcel, ed., *Degas Letters* (translated by Marguerite Kay), Cassirer, Oxford, 1947

Halévy, Daniel, *My Friend Degas* (translated and edited by Mina Curtiss), Wesleyan University Press, Middletown, Connecticut, 1964

Janis, Eugenia Parry, *Degas Monotypes,* Fogg Art Museum, Cambridge, Massachusetts, 1968

Jeanniot, Georges, "Souvenirs sur Degas," *La Revue Universelle,* LV, 15 October 1933, pp. 152–74; 1 November 1933, pp. 280–304

Lemoisne, Paul-André, *Degas et Son Oeuvre,* 4 vols., reprint edition, Garland Publishing, New York and London, 1984

McMullen, Roy, *Degas: His Life, Times and Work,* Houghton Mifflin Company, Boston, 1984

Millard, Charles W., *The Sculpture of Edgar Degas,* Princeton University Press, 1976

Moreau-Nélaton, Etienne, "Deux Heures avec Degas," *L'Amour de l'Art,* 12th year, July 1931, pp. 267–70

O'Brian, John, *Degas to Matisse: The Maurice Wertheim Collection,* Harry N. Abrams, New York, 1988

Orienti, Sandra, *Degas,* Thames and Hudson, London, 1969

Pickvance, Ronald, *Degas 1879* (exhibition catalogue), National Galleries of Scotland, Edinburgh, 1979

Reed, Sue Welsh, and Barbara Stern Shapiro, *Edgar Degas: The Painter as Printmaker,* Museum of Fine Arts, Boston, 1984

Reff, Theodore, *Degas: The Artist's Mind,* The Metropolitan Museum of Art, Harper and Row, New York, 1976

———, *The Notebooks of Edgar Degas,* 2 vols., Hacker Art Books, New York, 2nd revised edition, 1985

Rewald, John, *Degas, Works in Sculpture: A Complete Catalogue,* Pantheon Books, New York, 1944

———, *The History of Impressionism,* Museum of Modern Art, New York, 4th revised edition, 1973

———, *Studies in Impressionism,* Harry N. Abrams, New York, 1986

Rich, Daniel Catton, *Degas,* Harry N. Abrams, New York, 1951

Shackelford, George T. M., *Degas: The Dancers* (exhibition catalogue), National Gallery of Art, Washington, D.C., 1984–5

Sutton, Denys, *Edgar Degas: Life and Work,* Rizzoli, New York, 1986

Terrasse, Antoine, *Edgar Degas,* Doubleday, Garden City, New York, 1974

Thomson, Richard, *The Private Degas* (exhibition catalogue), Whitworth Art Gallery, Manchester, and Fitzwilliam Museum, Cambridge, England 1987

———, *Degas: The Nudes,* Thames and Hudson, London, 1988

Valéry, Paul, *Degas Danse Dessin,* Gallimard, Paris, 1965

———, *Degas Manet Morisot* (translated by David Paul), Bollingen Series XLV:12, Pantheon Books, New York, 1960

Vollard, Ambroise, *Degas: An Intimate Portrait* (translated by Randolph T. Weaver), Greenberg, New York, 1927

List of Illustrations

Index

Acknowledgments

We would like to thank all the members of the committee of the Degas exhibition that was held in Paris, Ottawa, and New York in 1988: Jean Sutherland Boggs, Michael Pantazzi, Gary Tinterow, Douglas Druick, and Anne Roquebert. Without the catalogue we wrote on that occasion, *Degas* (Metropolitan Museum of Art, New York/National Gallery of Canada, Ottawa), this book could not have been produced in its present form.
Illustration research: Odile Felgine

Photograph Credits

Caroline Abitbol (during the shooting of *The Little Fourteen-Year-Old Dancer*, a film by H. Alekan) 1, 2. Albright-Knox Art Gallery, Buffalo 146. All rights reserved 13a, 27, 62, 65, 75b, 100, 106b, 111, 114–5, 118–9, 121br, 128, 139, 174–5. Archives Durand-Ruel 75a. Artephot/Artothek 87. Artephot/Bridgeman 58, 60, 97, 112, 127b. Artephot/Cercle d'Art 41r. Artephot/Faillet 41l, 46r, 47l. Artephot/A. Held 116, 142. Bibliothèque Nationale, Paris 10, 17r, 19b, 20, 59, 70b, 78a, 94, 96, 98b, 99a, 99b, 103, 104, 115a, 117, 120–1, 121a, 126, 129, 131, 133, 135, 136, 143, 144–5, 160, 164–5, 166, 167, 171. Bridgeman/Giraudon 93. Brooklyn Museum, New York 50–1. Carnegie Museum of Art, Pittsburgh 92a. Christie's, London 88–9. City Museum and Art Gallery, Birmingham, England 25al. Collection Sirot-Angel 17l, 51r, 57b, 140, 158, 163. Dumbarton Oaks Research Library and Collection, Washington, D.C. 29l. Edimédia 36, 137, 156, back cover. Editions Gallimard 154–5. Fitzwilliam Museum, Cambridge, England 76a. Olivier Garros 53ar, 53br, 54–5, 79b, 90, 110a, 124a. Graphische Sammlung, Staatsgalerie, Stuttgart 67a. Kitakyushu Municipal Museum of Art 48–9. Laboratoire des Musées de France 36b. Leicestershire Museums and Art Galleries, Leicester, England 125b. Metropolitan Museum of Art, New York 14–5, 38–9, 47r, 52–3, 56, 68–9, 82–3, 106–7, 124bl. Musée Cantonal des Beaux-Arts, Lausanne, Switzerland 127a. Museum of Fine Arts, Boston 32, 44–5, 46l. National Gallery of Art, Washington D.C. 100–1. National Gallery of Canada, Ottawa 25ar, 141. National Gallery of Scotland, Edinburgh 25b. National Portrait Gallery, Washington, D.C. 102. Ny Carlsberg Glyptotek, Copenhagen 124br. Oeffentliche Kunstsammlung, Kunstmuseum, Basel 122–3. Ordrupgaardsamlingen, Copenhagen 70a. Philadelphia Museum of Art 80. Photo Lontin, Lyons 16. Réunion des Musées Nationaux, Paris 3, 4, 5, 11, 12, 13b, 18, 18–9, 22, 22–3, 24–5, 26a, 26bl, 26br, 28, 29ar, 29br, 30–1, 33, 34, 35a, 35b, 37, 40, 42–3, 49r, 57a, 60–1, 62–3, 64, 71, 72–3, 74, 76b, 77, 79a, 80–1, 82, 84–5, 86, 90–1, 91r, 95, 98a, 105, 108, 109, 110b, 113, 114, 125a, 130, 132, 134, 148, 150, 153, 162, 168, 172, 173, 175a, 176, 177, 178, 179, 180, 181, 182–3, front cover. Scala, Florence 151. Smith College Museum of Art, Northampton, Massachusetts 21. Städtische Galerie im Städelschen Kunstinstitut, Frankfurt 66a, 66b, 67b. Sterling and Francine Clark Art Institute, Williamstown, Massachusetts 8, 78b

Text Credit

Grateful acknowledgment is made for use of material from *Degas: The Complete Etchings, Lithographs and Monotypes*, by Jean Adhémar and Françoise Cachin, translated by Jane Brenton, Thames and Hudson, London, 1986 ("Degas and Brothels")

Henri Loyrette is chief curator at the
Musée d'Orsay, Paris. After a stint at
the French Academy in Rome (1975–7), he published
many studies on 19th-century French art, including one on
Gustave Eiffel. He served on the committee of the
Degas e l'Italia exhibition in 1984 (Villa Medici, Rome)
and on the French committee of the Degas
retrospective at the Grand Palais, Paris.

Translated from the Fren

Project Manager: Sharon AvRutick
Typographic Designer: Elissa Ichiyasu
Cover Designer: Robert McKee
Editorial Assistant: Jennifer Stockman
Design Assistant: Penelope Hardy

Library of Congress Catalog Card Number: 92–82809

ISBN 0–8109–2897–3

Copyright © 1988 Gallimard

English translation copyright © 1993 Harry N. Abrams, Inc., New York,
and Thames and Hudson Ltd., London

Published in 1993 by Harry N. Abrams, Incorporated, New York
A Times Mirror Company

Printed and bound in Italy by Editoriale Libraria, Trieste